IMAGES
of America

LEWIS COUNTY

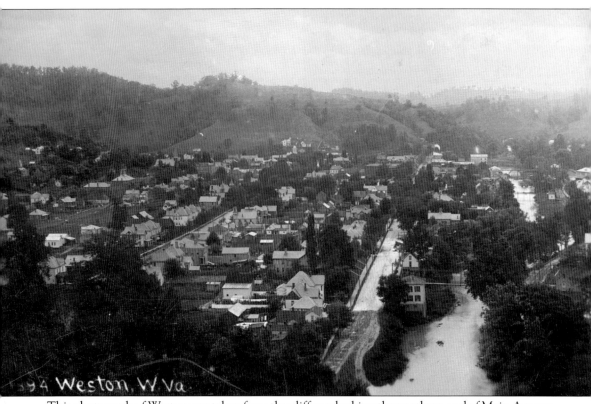

This photograph of Weston was taken from the cliff overlooking the northern end of Main Avenue by G. H. Broadwater, a Thomas, West Virginia, photographer who passed through Weston a century ago. His images flesh out the picture of the community as captured by local photographers like Gissy and Ellis. In this image, Main Avenue was only paved to the 500 block, and three bridges, all of them steel, spanned the West Fork River. The smallest bridge, a footbridge, crossed just below the home historically known as the Warren-Sleigh house. The other two were both later replaced by the concrete bridges now on site at the West Fourth Street and West Second Street crossings. (Courtesy of Bradley R. Oldaker.)

ON THE COVER: The Trans-Allegheny Lunatic Asylum was referred to by numerous names during its 136-year use as a hospital. Even today most local residents call it simply "the asylum." This image can be dated to before 1938, when a fire destroyed the interior and roof of the multi-storied wing on the far right, burning the smaller tower (like the other three that are visible) that graced its height. The large field in front of the hospital was the playing field for the local high school football team until 1938. (Courtesy of Hacker's Creek Pioneer Descendants.)

IMAGES of America
LEWIS COUNTY

Joy Gilchrist-Stalnaker
and Bradley R. Oldaker

Copyright © 2010 by Joy Gilchrist-Stalnaker and Bradley R. Oldaker
ISBN 978-0-7385-8585-7

Published by Arcadia Publishing
Charleston SC, Chicago IL, Portsmouth NH, San Francisco CA

Printed in the United States of America

Library of Congress Control Number: 2009943080

For all general information contact Arcadia Publishing at:
Telephone 843-853-2070
Fax 843-853-0044
E-mail sales@arcadiapublishing.com
For customer service and orders:
Toll-Free 1-888-313-2665

Visit us on the Internet at www.arcadiapublishing.com

This book is dedicated to the generations of local historians and photographers who, through the decades, have preserved the past of Lewis County in both writing and image.

CONTENTS

Acknowledgments		6
Introduction		7
1.	Pre-1900 Weston	9
2.	Post-1900 Weston	23
3.	Weston Hospital	63
4.	Lewis County Communities	71
5.	Events, Recreation, and Sports	95
6.	Crisis, Conflict, and Adversity	103
7.	Industry and Development	113

Acknowledgments

To compile a photographic record of Lewis County requires the work of generations of historians and photographers. Without their prior efforts, none of this book would have been possible. Early works such as Edward Conrad Smith's *History of Lewis County, West Virginia* and later county histories were important resources in the preparation of this book. An invaluable resource to the authors was the unpublished manuscript by the late local historian Bill Adler, *Walking Tour of Historic Weston*. It is hoped that this incredible work will soon be available for all to enjoy.

We thank the many individuals who have opened their private photographic collections to us and permitted us to borrow and scan their images. In particular, we thank Jerry Cobb of Davis Studio who allowed us access to the Davis Studio collection and scanned or printed for us countless photographs. We also thank Bob Billiter and the *Weston Democrat* for permitting us to review and use the decades of photographs they had in storage. We further thank Otis Reed and Dannie Gum for their assistance in completing this book. The greatest difficulty in completing this work was choosing from the many photographs made available to us and selecting the images. Unfortunately, we could not include all the images we wanted to publish.

Finally, we would thank Hacker's Creek Pioneer Descendants, who opened up to us their photographic archive of the county. Without access to these images, this book would have been quite difficult and incomplete.

The identifications and captions in the book are based upon the best information available to us. We welcome information, comment, or further identification regarding any of the images published in this book. We hope the readers enjoy these photographs and recall past memories as they view them.

The following is a key to abbreviations used in the photograph credits throughout this book: Bailey, Stultz, Oldaker, and Greene, PLLC (BSOG); Bradley R. Oldaker (BRO); Hacker's Creek Pioneer Descendants (HCPD); *Weston Democrat* (WD); West Virginia Museum of American Glass (WVMAG); and West Virginia Regional and History Collection, West Virginia University Libraries (WVRHC).

INTRODUCTION

Six years from the date of this printing (2010), Lewis County will celebrate its bicentennial. Surely its citizens will review its long history as they look toward its future. Undoubtedly they will call upon the several written histories to help them in their task. Those written histories stretch back to the region's earliest times, especially to the days when the first European hunters and settlers crossed the Allegheny Mountains and established a foothold first along the banks of the Buckhannon River at the mouth of Turkey Run and then further west on the waters of what today is called Hacker's Creek in Lewis County.

They battled the elements and sought some solution to peace with the Native Americans they found there. They tenaciously located homesteads. They grabbed bits of sunshine that shone through the huge canopy of trees that covered the howling wilderness to plant and harvest crops for man and beast. They raised the bar and others followed them. At first in trickles of humanity crossing the Allegheny Mountains from diverse cultures, then in greater numbers, the hardy Europeans, particularly the Scots-Irish and the Germans, saw that the land was good despite the backbreaking work required to tame it.

Realizing they were in a land where the only law was one person's word against another, the pioneering people organized themselves with courts and laws and displayed the civilities that are conducive to good human behavior. They built schools and churches, roadways and bridges. They opened shops and banks and struggled to eke a living from the hills and valleys that blanketed the 1,754 square miles then making up the county.

Nowhere else was it any more true that brother fought brother and father fought son than in Lewis County during the American Civil War. When the conflict was over, families came back together and joined with newly arriving immigrants from England, Ireland, Scotland, Germany, and Austria to fan the flame of industrialization that had begun before the war. Now Lewis' people were building railroads, pushing forward with the development of oil and gas, harvesting the virgin forests to provide timber to build homes and factories, and even completing the construction of the Trans-Allegheny Lunatic Asylum, where thousands of patients would be treated over the years.

While there were still large numbers of people dwelling in the rural areas of the county and making their living from farming, growth in the extraction industries provided the resources necessary for the skilful manufacture of fine glass. This industry served as the backbone of the local economy for three-quarters of the 20th century.

Life in Lewis County, like life throughout the nation, began to change drastically on December 7, 1941, with the events at Pearl Harbor. The county's young men, and later married men and those with families, were drafted to fight the war on two fronts, one in Europe and the other in the Pacific. Others, as well as some women, enlisted voluntarily. When hostilities ceased in 1945, many of them came home; others did not. Some were killed in action or died of war wounds. Others chose to make their homes in other parts of the state or the nation.

Those who came back eventually adjusted to life in a world more industrialized than the one they had left behind. Some took up farming again. Some went to work in the glass factories. Others moved to places like Akron, Ohio, and Baltimore, Maryland, where work was more plentiful.

Although they left in person, they did not leave in spirit. Perhaps no people anywhere are more attached to their homeland than native West Virginians. And they did not forget it. It was and still is to this day a common sight to see a line of cars bearing license tags from Ohio and Maryland and North Carolina streaming homeward to the hills of West Virginia on Friday night and a reverse flow back to the land of their work on Sunday afternoon.

Those who remained behind gradually moved forward to keep up with a faster pace of living. Not without growing pains did they adopt new technology, like television in the 1950s and computers in the 1980s.

Their biggest struggles, though, were with those agencies who believed they were helping the state's residents to a better life. They struggled when the state and federal governments sought their lands to build newer and bigger highways. The four-lane U.S. Highway 33 now runs eastward from Weston to the West Virginia–Virginia border. Interstate highway I-79 cuts through the heart of the county and carries traffic from Canada to far away Florida via its juncture with I-77 in Charleston.

First they dealt with Monongahela Power Company as it purchased 3,000 acres, the greater portion of which was in Lewis County, to dam Stone Coal Creek and create Stone Coal Lake and Stonecoal Wildlife Management Area. This was a hydroelectric project but also was one of a series of projects meant to stem the flow of flood waters in Weston and downstream from there. Others included the eight watershed dams built on Polk Creek. While all nine dams successfully achieved their goals and saved much property from destruction by flood, only one, Stonecoal Lake, resulted in a creation that would prove to be beneficial for the displaced families and the community as a whole. It became and still is a favored fishing place where muskies are said to grow to monster sizes.

Then the battle to build a dam to hold back the waters from the upper tributaries of the West Fork River that had been raging since the 1930s came screaming to an end. The Army Corps of Engineers acquired property, sometimes with the aid of U.S. Marshals, and began the arduous process of building the Stonewall Jackson Dam to hold back the waters of the river's upper estuaries. It was finally dedicated in 1990.

Through most of these struggles, the World War II veterans and their younger brothers of the Korean War with their respective families held on. Then came the Vietnam era and the war that many did not want to fight. Some were drafted and others signed up to fight. Regardless, when these men and women came home, they frequently were met with disdain and sometimes outright nastiness.

The manufacture of fine glassware was still a major industry in Lewis County in the 1970s and 1980s. But in 1994, with the signing of the North American Free Trade Agreement, the glass industry headed south to Mexico and never recovered. Today the only real remnants of this once mighty industry are a couple of very small shops where one or two men are working, and the West Virginia Museum of American Glass.

As the calendar moved toward the 21st century and Y2K, dread was in the air. Computers were not equipped to handle the switch to the new century and people everywhere were frightened about what would happen. Thanks to plenty of preparation, the world survived and so did Lewis County.

Now, the county and its people are well into the new century. Still its people live and die, make everyday decisions, and move on with their lives. What the next century will bring one can only guess.

One
PRE-1900 WESTON

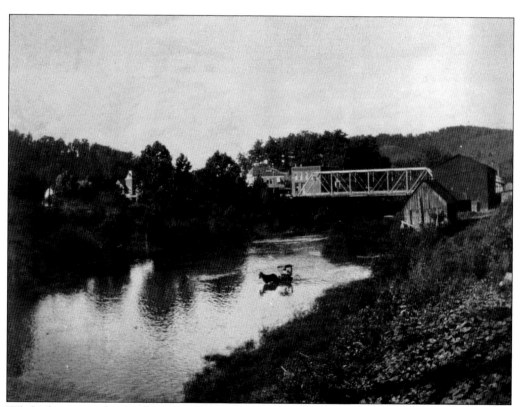

While the reason for this horse and buggy being in the West Fork River near the West Second Street bridge is unknown, the driver's ability to cross here demonstrates the shallowness of the stream at this point. The shallowness was created by the widening of the riverbanks in the 1860s and 1870s when blue sandstone was cut from the banks to build the mental hospital. (Courtesy of Davis Studio.)

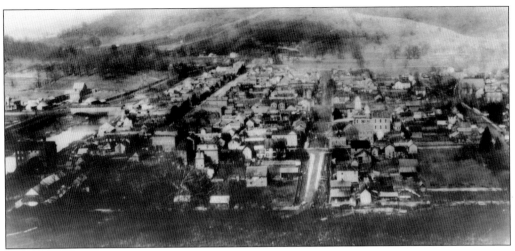

This c. 1890 view of Weston looks north across the town. On the left side of the photograph, the covered bridge connecting Weston with West Second Street is plainly visible. This was the second bridge to span the West Fork River at this location. Built in the late 1840s and repaired in 1858, the bridge was razed in 1890. The area that is now River Avenue is virtually undeveloped in this early view. (Courtesy of Betty Reed.)

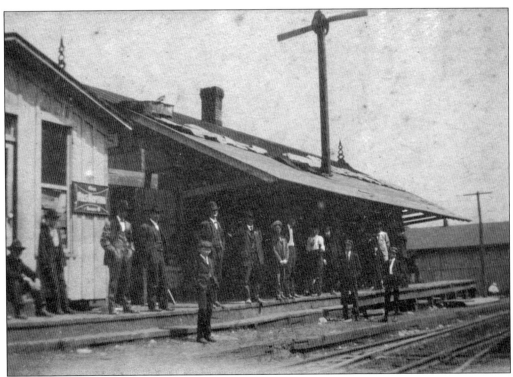

This early image was acquired with other local photographs from an album. The caption identified the structure as "old railroad station when first built in Weston." The original image was produced using a cyanotype (blue) process and was mounted on a card with no identifying markings. (Courtesy of BRO.)

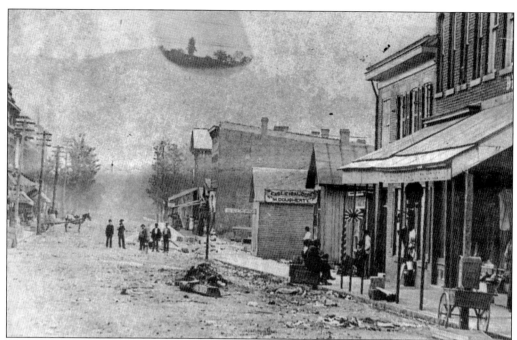

This view of Main Avenue looks north from First Street. In the middle of the photograph to the right is the Eagle Saloon. Large stepping-stones are visible across Main Avenue at the center of the photograph. Early local newspaper editorials sarcastically mention people falling from the stones into the muddy streets, never to be heard of again. (Courtesy of WD.)

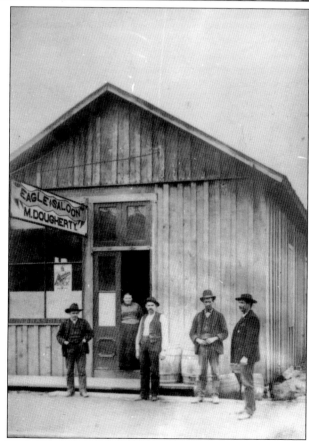

The Eagle Saloon was the first of three saloons owned by Michael Dougherty at what is now 132–134 Main Ave. in Weston. Mrs. Dougherty stands in the doorway, Elmer Straw is at the far left, and Col. Joe Fuccy on the far right. This single-story frame building burned in a business section fire in November 1889. It was replaced by a three-story brick building that burned in the great business section fire of December 1894. (Courtesy of Bergin Sleigh Collection, HCPD.)

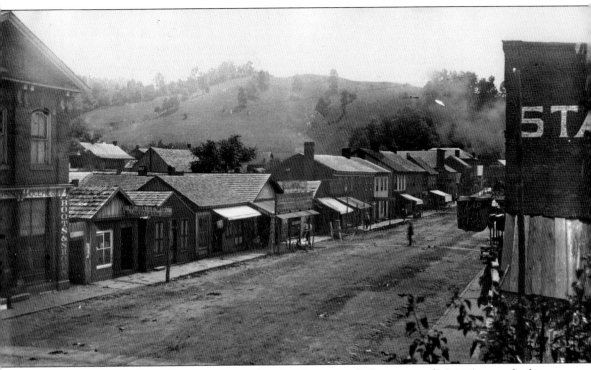

Thomas Dwight Biscoe (1840–1930) and Walter Biscoe took this image of Main Avenue looking southeast at 2:00 p.m. on July 10, 1884, from a window of the Bailey House (located on the corner of Main Avenue and Second Street where the Citizen's Bank now stands). In 1884, Thomas Biscoe, a professor of natural science at Marietta College, traveled throughout West Virginia taking photographs and recording details of his images. He then developed them in his home photographic studio from glass negatives. This image shows the recently constructed George Ross Store on the corner of Main Avenue and Second Street. The next business on the east side of Main Avenue has a sign reading "Mrs. Ida Lewis Millinery & Straw Goods" in front. The next structure is unidentified, and the fourth business is Harrison and Warren Hardware. Next to the hardware store is a boot and shoe shop. On the west side of Main Avenue, a banner can be seen for Star Clothing located in the Ralston-Edmiston Building. At the intersection of Main Avenue and First Street, the sign on the front of the Weston House hotel is visible on the original image. (Courtesy of WVRHC.)

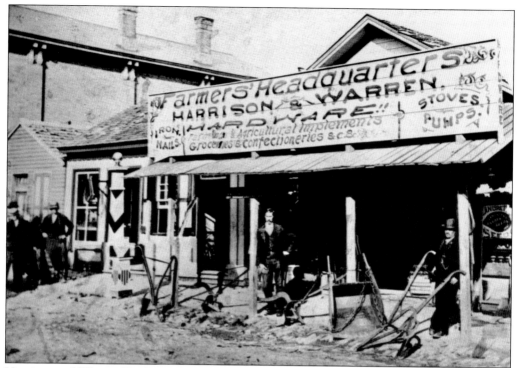

Harrison and Warren Hardware, located in what was referred to as the "Edwards Block" of Main Avenue, can be identified in the center of the photograph on the previous page. The sign advertises "Farmers' Headquarters" with merchandise including groceries, confectionaries, stoves, pumps, nails, iron, and farming implements. The building next to the hardware store appears to have a barber's pole in front of it. (Courtesy of Davis Studio.)

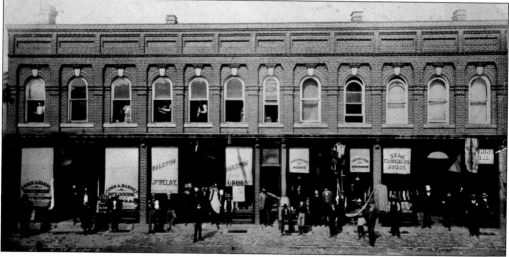

This 1884 image of the Ralston-Edmiston building at 165–173 Main Ave. shows the storefronts, from left to right, of John A. Barnes Groceries and Drygoods, Ralston's Jewelry and Drug Store, James B. Finster Books and Stationery, and Star Clothing House. At one time, this 1879 structure was home to Weston's first lending library and telephone exchange. Today the building is occupied by Drs. Brannon and Brannon and the Weston Sanitary Board. (Courtesy of Davis Studio.)

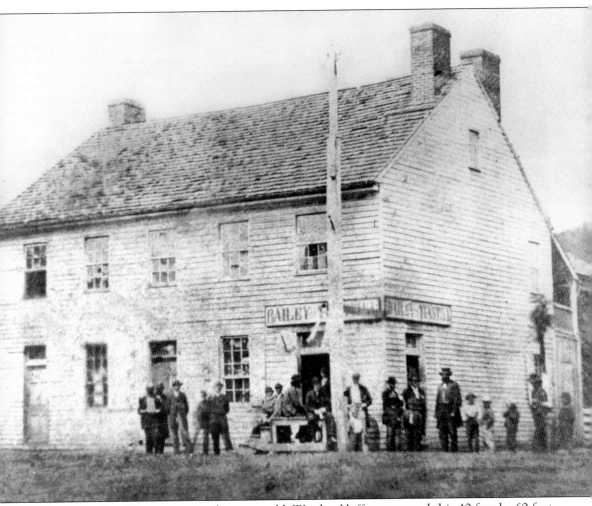

In 1822, when Weston was just four years old, Weeden Hoffman erected this 40-foot-by-60-foot log and frame building to house his general store and an inn. It was located on the southwest corner of Main Avenue and Second Street, about where the Property Shop now stands. Later purchased by Maj. Thomas Bland and then, in 1832, by Minter Bailey, it soon became known as the Bailey House. The Bailey House rapidly became the preferred lodging for travelers because of its outstanding service. It was in this structure that a young Thomas J. (later "Stonewall") Jackson took his admission examination to West Point. In 1851, Bailey completed a new, three-story brick hotel where the Citizens Bank now stands. The old structure again became a general store. The building in this photograph burned in a business section fire on November 1, 1877. In a 1930 article, historian Roy Bird Cook identified the following men in this *c.* 1865 photograph: David Bare, Dr. Thomas Camden, Judge Matthew Edmiston, John S. Camden, and Andrew Edmiston. (Courtesy of Davis Studio.)

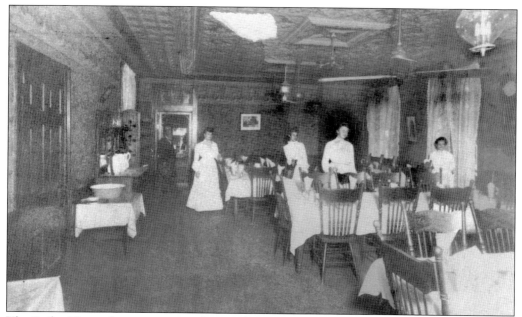

The Bailey House dining room was famous for its crusty fried chicken, a delight created about 1871 by a pair of sisters surnamed Lee who were former slaves. The chicken was such a hit that customers demanded it be on the restaurant's daily menu. According to the late Bill Adler, a noted county historian and seeker of interesting facts, 244,012 chickens met their fate in the Bailey House before it closed for all time in 1927. (Courtesy of HCPD.)

Travelers Thomas and Walter Biscoe probably were lodging at the Bailey House when they captured this unusual image of the "hotel court" at the rear of the second Bailey House located on the present site of the Citizen's Bank, on July 10, 1884. (Photograph by Thomas and Walter Biscoe; courtesy of WVRHC.)

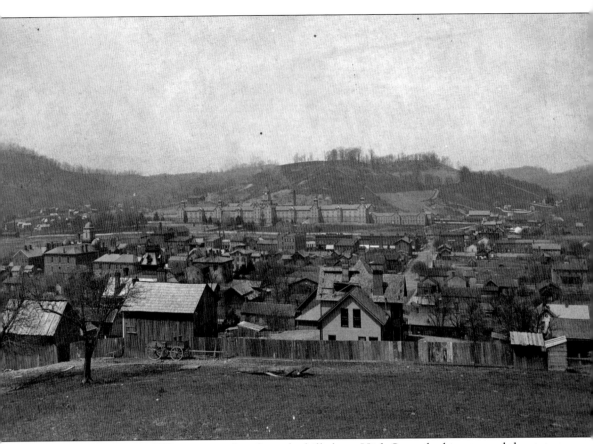

This c. 1890 view of Weston was taken from the hill above High Street looking toward the state hospital. The original image is so sharp that when enlarged the sign on the front of the Bailey House several blocks away can be read. The years between 1880 and 1900 were a boom period for Weston. With the coming of the railroad in 1879, Weston was well located to be a manufacturing center. Although the glass industry would not arrive for a number of years, Weston had other important businesses located there, including Herb Medicine Company, manufacturer of Lightning Hot Drops; Horseshoe Bedspring Company, in 1888; and Lewellen's carriage factory. Weston was in the midst of a building boom, which in 1889 caused the adoption of an ordinance prohibiting the erection of wood buildings in certain circumstances, given the fear of fire destroying the town. In 1890, the capital was raised locally for an electric light plant and by April 1, 1891, Weston had electricity. In 1891, a short stretch of Main Avenue above Second Street was paved with brick. (Courtesy of Minter Ralston III.)

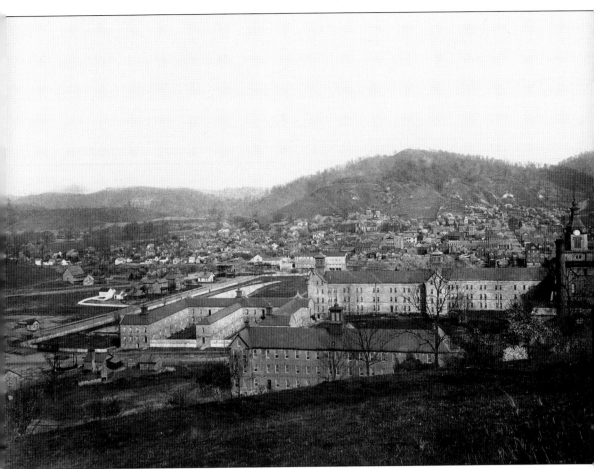

This rare companion picture to the image of Weston on the facing page by the same unknown photographer was taken from the hill behind the state hospital around 1890. The fence around the hospital was wooden, and the train depot, now called the city building, had not yet been built. There is a large water impoundment between the hospital and West Second Street. Noticeably absent in the photograph is a bridge on West Second Street connecting Weston with the state hospital. The West Fork River previously was spanned by a covered bridge. In a state of serious disrepair, the covered bridge was torn down in 1890, and an iron bridge was completed in June 1891. This photograph and the photograph on the opposite page were captured following the destruction of the old bridge and before the construction of the new bridge had begun. (Courtesy of Minter Ralston III.)

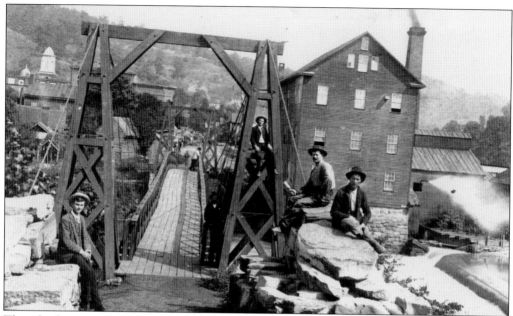

Three bridges over the West Fork River have linked the west end of First Street with the entrance to the former Trans-Allegheny Lunatic Asylum. The first bridge, above, was suspended from cables and constructed of wood. Built in 1886–1887, it burned in the great business district fire of March 1896. The second bridge, below, was an iron span bridge built in 1897. It served the community for 87 years before being replaced by the present bridge in 1984. The old gristmill, seen at the right in both pictures, was operated by various owners from 1817 to 1921. (Above, courtesy of Betty Reed; below, courtesy of BRO.)

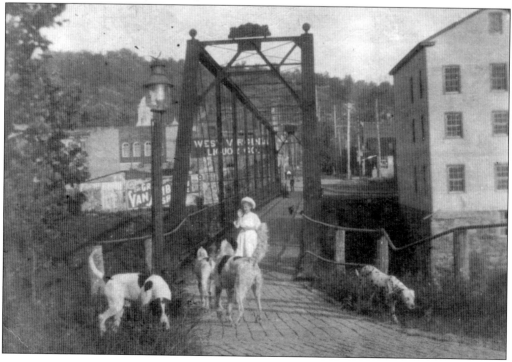

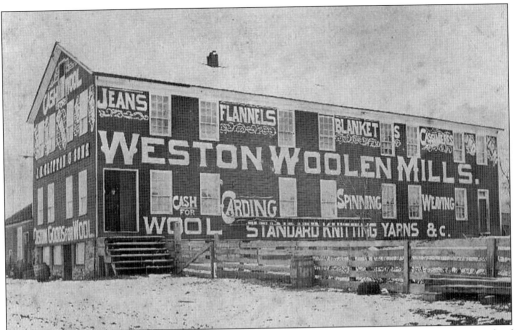

About 1870, Joseph H. Clifton, a Pennsylvanian, took advantage of the proximity of the thousands of sheep then being raised in the county and started the Weston Woolen Mills in West Weston. Clifton advertised his wares to all passersby with bold signs on his main building. The plant, photographed here in 1883, burned in February 1885. It was never rebuilt. (Courtesy of Betty Reed.)

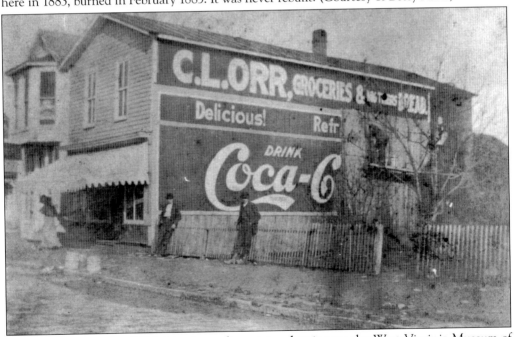

This building stood at 248 Main Ave. adjacent to what is now the West Virginia Museum of American Glass. It had a variety of owners, including Cecil L. Orr. This image is especially interesting because a sign painter is working from a scaffold to paint the Coca-Cola sign. (Courtesy of HCPD.)

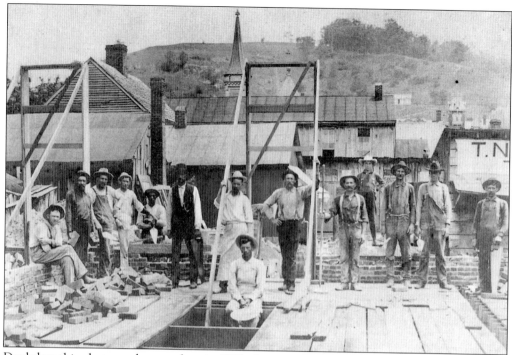

Doubtless this photograph was taken in 1895, the year construction was just beginning on St. Paul's Episcopal Church on the corner of Center Avenue and Second Street. The congregation began worshipping there in 1896, but the church was not dedicated until 1900. Visible in the background is the steeple of the second St. Patrick Catholic Church, which served its congregation from 1876 to 1915. (Courtesy of Betty Reed.)

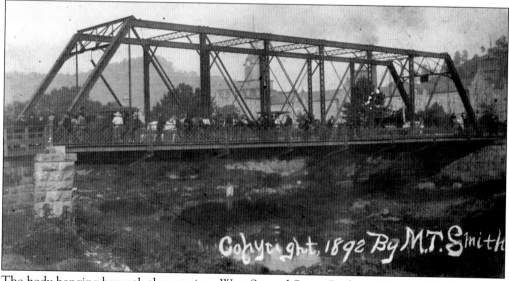

The body hanging beneath the new iron West Second Street Bridge is 22-year-old Edgar Jones, a black man. He was lynched by a mob on the night of July 6, 1892, for stabbing and killing Michael Tierney, 25, in the kitchen of the Commercial Hotel, a building then located at what is now 109–113 Main Ave. No one was ever prosecuted for Jones's death. In 1892, prints of this image were sold by M. T. Smith for 35¢. (Courtesy of Dick Duez.)

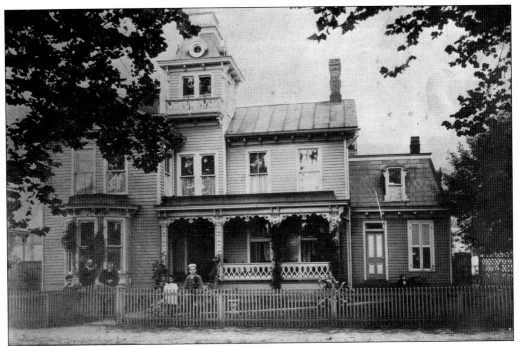

This house was owned by Thomas M. and Dora Hood when this photograph was taken in 1897. They sold it in 1898 to Ella Klein. It changed hands a number of times before it was sold to the Catholic Church in 1914. The house was demolished to make way for St. Patrick's School, which now stands on the site on lot 12, Center Avenue. (Courtesy of BRO.)

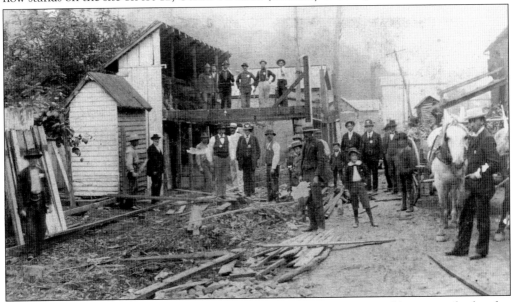

Although laid out in 1817, some Weston streets and alleys were not open to public passage for decades. Er Ralston and others "appropriated" these ways for buildings or vegetable gardens. In May 1899, after an 11-year court battle, a crew of men, accompanied by badge-wearing constables, appeared on Ralston's premises, climbed onto the barn's roof and began cutting through the building, ridge beam to sill, right on line with the Water Street boundary. (Courtesy of Minter Ralston III.)

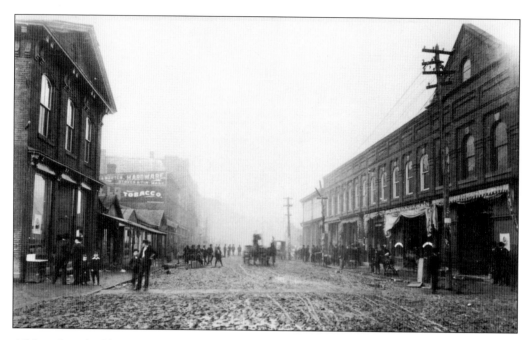

All but three buildings on both sides of Weston's Main Avenue in the block between First and Second Streets burned in the 1890s. These two images were taken after the fire on March 29, 1896. The top picture is looking from the north end of the block, while the bottom picture is a view from the south end of Main Avenue. The only buildings standing on the west side of the street following the fire were those that now house the Weston Sanitary Department, the Drs. Brannon offices, and the corner building at 177 Main Ave. where The Property Shop is now. (Above, courtesy of HCPD; below, courtesy of Betty Reed.)

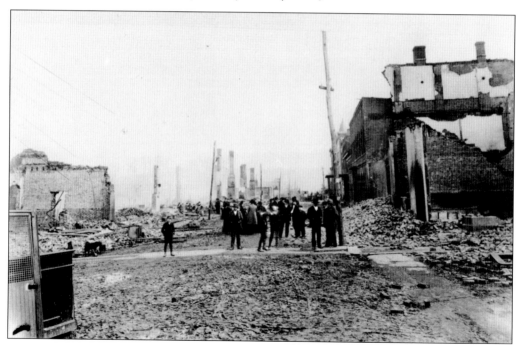

Two
POST-1900 WESTON

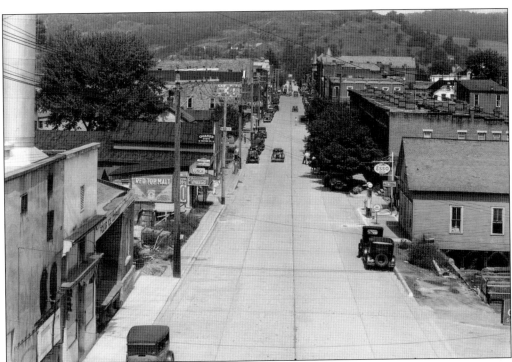

Shown from left to right on the left side of this 1934 northbound view of Main Avenue are the storage building for the Monongahela Power Company, the collections office for the West Virginia Water Company, and Polar Ice. The platform where ice trucks were loaded for delivery is visible. The lunch stand was operated by the Heater family and later by "Ma" Bragg. The Weston Laundry was on the right, beside the Esso station. (Photograph by Archie Ellis; courtesy of HCPD.)

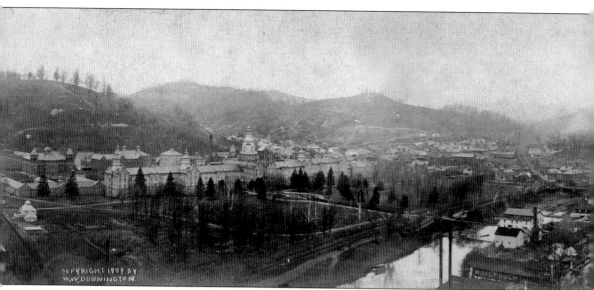

This 1909 panoramic view of Weston was taken by Weston photographer William W. Dunnington (c. 1865–1927). As the earlier 1880 to 1900 period in Lewis County was heavily influenced by the coming of the railroad, the early 20th century was shaped by the discovery and development of oil and gas in the county. In 1900, Lewis County was second in the state in the cattle industry; however, with the payment of royalties to landowners and the comparatively high wages paid by

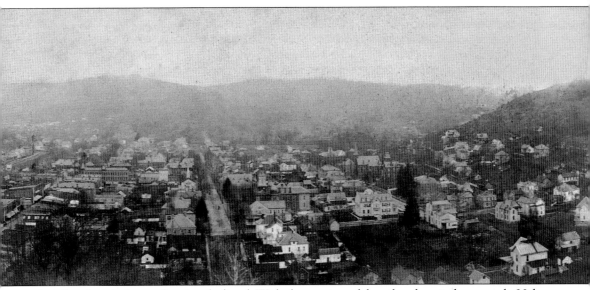
the oil and gas industry, farming declined. With the coming of the oil and gas industry, early-20th century Weston boomed with new businesses and an increase in population. As a result of the availability of inexpensive gas, the foundation was laid for the development of the glass industry. In 1903, the Crescent Window Glass plant opened, but by the time this photograph was taken, the hand-blown glass industry was in its infancy in Weston. (Courtesy of BRO.)

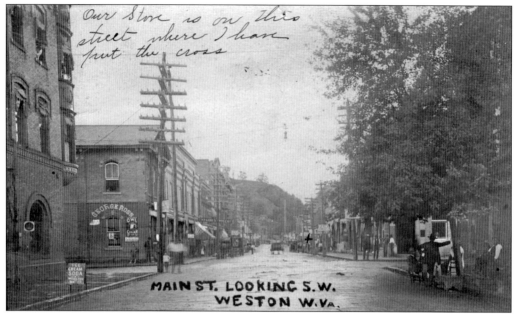

The four pictures on these two pages were taken in the heart of downtown Weston. This photograph looks up Main Avenue from in front of the Camden Hotel (now United Bank). The two-story George Ross store was located where Fashions Discount is in 2010. Photographer Louis Hiller emigrated from Germany and lived with his family in Weston for a brief period before moving to Clarksburg. (Courtesy of BRO.)

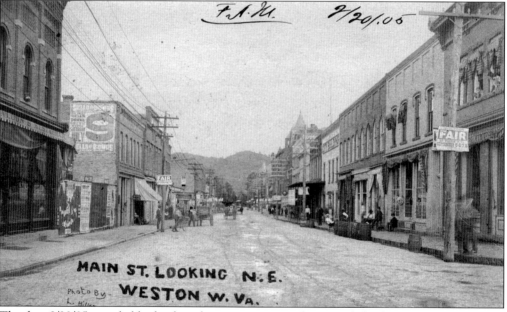

The date 2/20/05 is probably the date this picture postcard was mailed. The people in this image and the others on these two pages, all taken by the same photographer, were wearing lightweight clothing, which suggests summer weather. Also, a close review of the circus sign advertises the event as Saturday, July 9, a date that fell in 1904. This suggests the picture was taken in the earlier year. (Courtesy of BRO.)

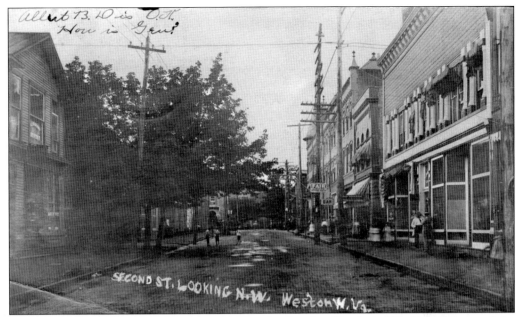

The buildings to the right are, from left to right, the Camden Hotel, the World Building, and the Forinash Furniture and Undertaking Company. Both were razed in 1974 to make way for the Weston National Bank (now United Bank) drive-through. Among the World Building's last tenants was the much-loved Harris's Candy Kitchen, operated by George Harris (Haveous), his wife, Jenny, and daughters Ann and Helen from before World War I until 1971. (Courtesy of BRO.)

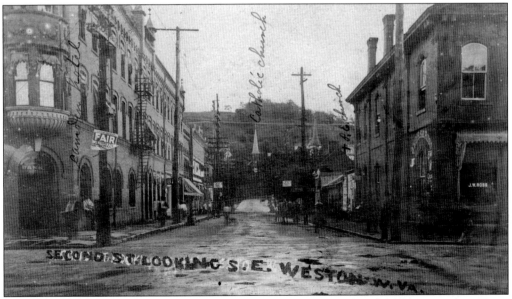

This image is the opposite of the one above and presents a view behind the photographer. Using the building on the left with the awning as the reference point, buildings from there to the corner of Second Street and Center Avenue were the World Building, the Forinash Furniture and Undertaking Company, and the Tracy Block (129–131 Second St.). In the background in the very center is the second building to serve as St. Patrick's Catholic Church (1878–1915). (Courtesy of Lawrence M. Chapman.)

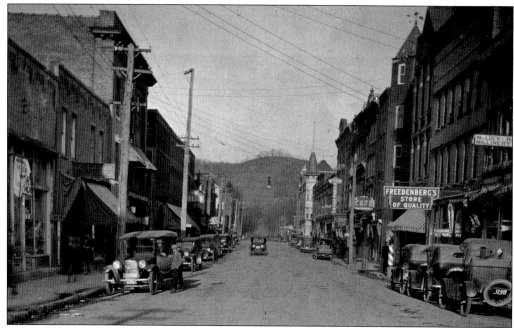

Weston's Main Avenue around 1925 was paved with brick and lined with businesses providing services to customers who came from near and far. The names of many of those stores are familiar to older county residents today, nearly 90 years later, either by the traces of their businesses left in signs painted on buildings or by the fact that some few remained on the scene well into the 20th century. (Courtesy of BRO.)

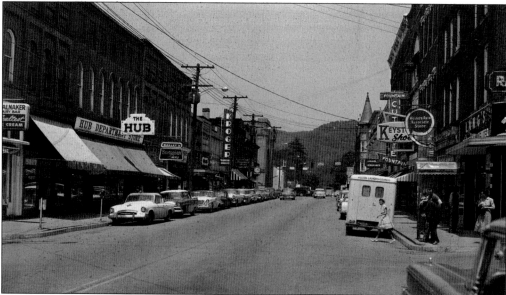

By the end of the 20th century, Weston's busy streets were less so. Loss of jobs, improved transportation, and a number of other factors caused county population to decrease from a high of 22,471 in 1940 to 19,711 in 1960. It decreased even further by 2000 to the all-time low of 16,919. Consequently, most of the shops lining Main Avenue when this photograph was taken in 1961 are long gone in 2010. (Photograph by Bob Davis, courtesy of Davis Studio.)

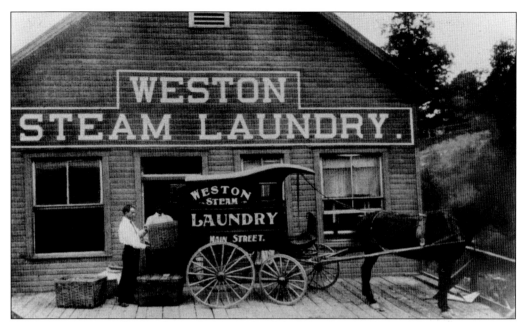

Weston Steam Laundry was located just north of the "Y" at 9 South Main Ave. It was owned and operated by James H. Bailey Jr. for 35 years, beginning in 1905. Renamed the Weston Steam Laundry and Cleaners in 1940 by new owners Albert D. Jarvis and James C. Bleigh, it remained a Weston fixture until late 1969, when it was sold to a Pittsburgh-based syndicate. (Photograph by Joseph B. Gissy; courtesy of BSOG.)

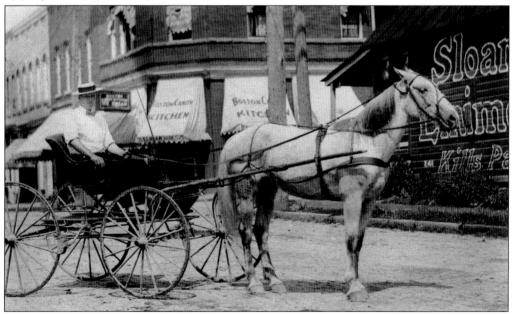

In horse and buggy days, horse owners were as proud of their horseflesh as new car owners are today. Many unidentified images of horse and owner are scattered through photograph collections. The building in the background is the Boston Candy Kitchen on the corner of Main Avenue and First Street. During the first half of the 20th century, several candy kitchens or confectioneries and soda fountains operated in Weston. (Courtesy of BRO.)

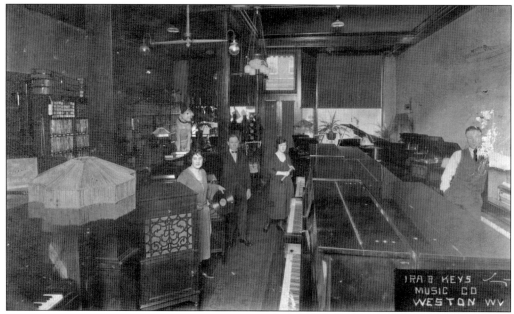

Even pianos could be purchased in Weston during its heyday. The Ira B. Keys Music Company was located at 108 Main Ave. and previously had been located at 131 East Second St. According to the 1928–1929 Polk Directory, they sold "everything musical" including Steinway and Weber Duo-Art Reproducing Pianos, Orthophonic Victrolas, and RCA Radiolas. It was one of 17 company stores in the state. (Courtesy of BRO.)

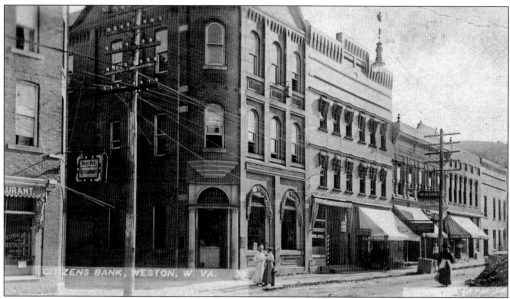

The Citizens Bank opened for business in a rented room in Michael W. Dougherty's new brick building (third building to the right) in February 1892. The next year, the bank's board of directors erected a building immediately to the north and thus gave the name Bank Alley to the narrow street running along its most northern side. This photograph was taken around 1913. The bank moved again in 1927 to its present location at the corner of Main Avenue and West Second Street. (Courtesy of BRO.)

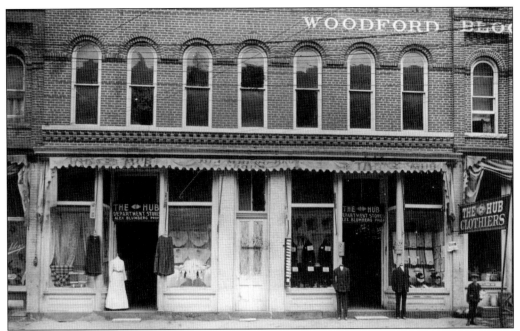

For 60 years, HUB Department Store operated as a successful business at the Main Avenue location occupied in 2010 by Roschell's Antiques and The Bargain Barn. Although owned and operated for a time by brothers from Baltimore, Michael and Alexander Blumberg, Alexander was the sole proprietor when this photograph was taken. The store advertised itself as the "originators of low prices in Weston." Another brother, Henry Blumberg, later took over the store. (Photograph by Joseph B. Gissy; courtesy of HCPD.)

A newsboy peddling papers on the corner of Main Avenue and West Second Street is backdropped by buildings around 1920. The central building was once Lewis County Bank and later Tierney Drug Store and Cain's Drug Store. To its left is T. P. Wright Book Store. To its right are West Second Street Sandwich Shop, Carper's Family Market, a barbershop, and an Esso (Exxon) station. The far building on that side is Cole Livery Stables. (Photograph by Archie Ellis; courtesy of HCPD.)

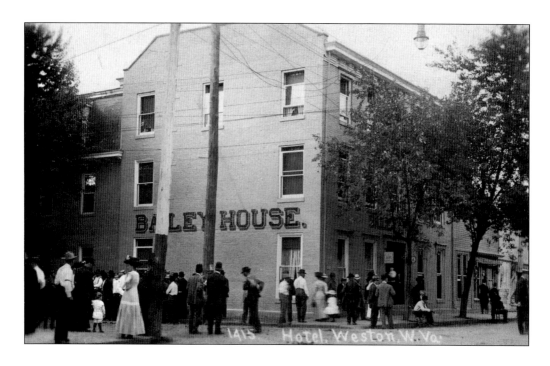

The photograph above, another taken by G. H. Broadwater on his visit to Weston on September 10, 1910, shows the crowd around the Bailey House, Weston's oldest inn, after the circus parade. A widely acclaimed hotel and restaurant, the Bailey House was constructed on the site of the present Citizen's Bank building in 1851 and closed in 1927. While there are several extant images of the front of the Bailey House, the view in the image below of its southern and western sides is seldom seen. The J. Wilsher Florist Shop is visible behind the Bailey House. (Above, courtesy of BRO; below, courtesy of Don Henderson.)

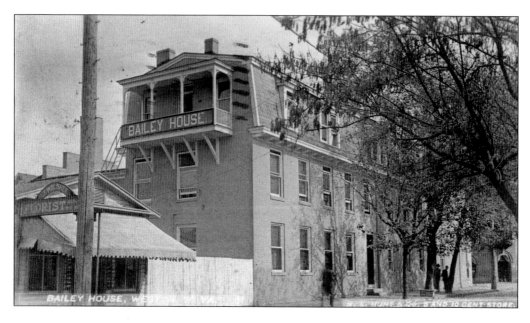

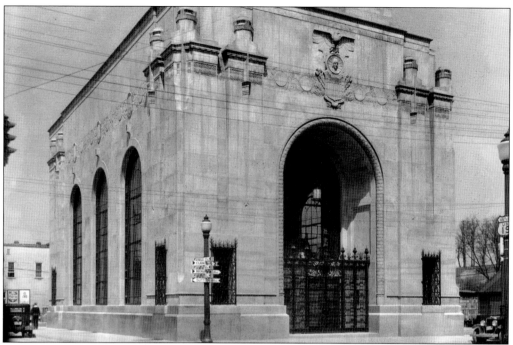

The Citizens Bank, which relocated from its former home on the southeast corner of Main Avenue and Bank Alley to its new home on the northwest corner of Second Street and Main Avenue in May 1930, is a marvel, not just for its architecture but also for its survivability. Founded in 1892, it was the newest bank in town, and this granite building was constructed when the Great Depression hit. The photograph above was taken when the bank officially opened for business on May 31, 1930. The photographer again visited the building on Tuesday, October 13, 1931, when the bank, the only one still operating in Weston, was closed by its board of directors to prevent a run on its cash assets. It reopened three years to the day later without any of its customers losing a penny of their savings. (Photographs by Archie Ellis; courtesy of HCPD.)

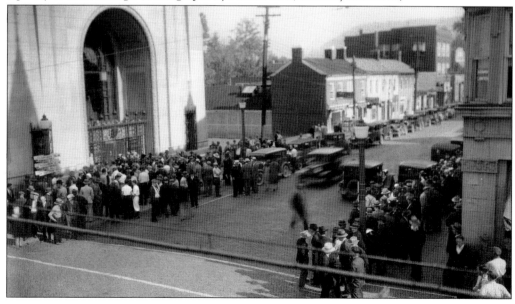

These buildings occupied the area where the parking lot for Citizens Bank on Main Avenue is now. On the far left, the side of the Bailey House can be seen. Next is a vacant lot and then a building where Er Ralston opened his jewelry store in 1856. The neighboring building was owned by Elias Fisher and was the site of the *Weston Independent* office from 1896 until 1978, when it ceased publication. (Courtesy of WVRHC.)

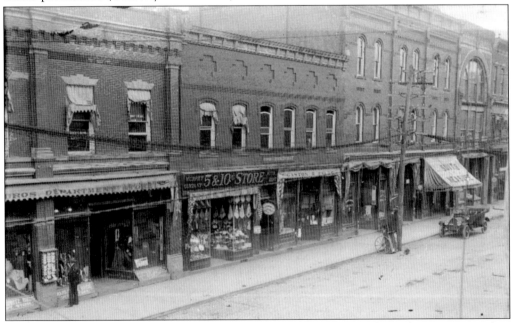

Murphy's 5 & 10¢ Store anchored Weston's business district for much of the 20th century. Murphy's opened in August 1913 in a building located where Fashions' Discount Clothing is now, and it later expanded into the building to the left. In 1970, these two buildings were renovated. The building at the corner of Second Street and Main Avenue was razed and a new corner structure built to form the building on the site today. Murphy's closed in 2001. (Courtesy of WD.)

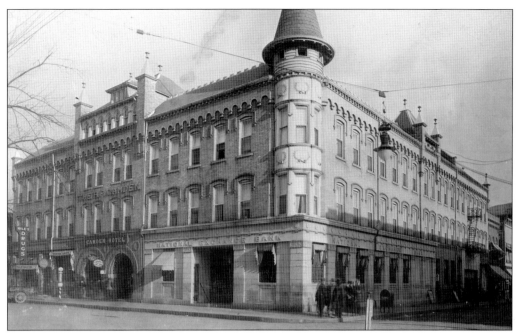

This building was Weston's largest commercial structure when it was built by R. P. Camden in 1896. It housed the National Exchange Bank where the United Bank is now, and the R. P. Camden Hotel (206–208 Main Ave.). It also housed the Camden Opera House, later called the Camden Theater, at 115 East Second St., a part of which is now the offices of the Lewis County Chamber of Commerce. (Courtesy of BRO.)

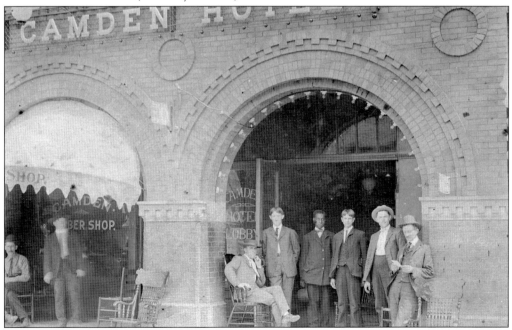

These men, whose identities are unknown, are lounging at the front entrance of the Camden Hotel. The façade of the entrance was remodeled when the hotel closed. It is now a part of the offices of the United National Bank. (Courtesy of HCPD.)

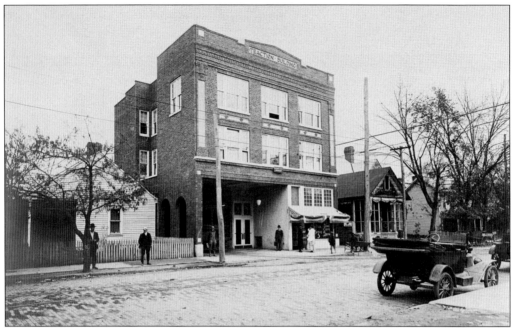

The Traction Building on Main Avenue was built by the Monongahela West Penn Traction Company as a terminal for the streetcars coming to Weston from Clarksburg and points north. This image was taken shortly after the building was completed in 1917. This building was remodeled and is today the law offices of Weber and Weber. (Courtesy of West Virginia State Archives.)

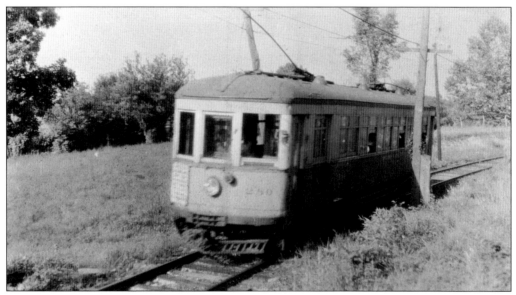

A streetcar line serviced Jane Lew, Weston, and points in between with service to Clarksburg from 1913 to 1946. It was built and operated by Monongahela Valley Traction Company before it became a part of Monongahela West Penn Public Service Company. The latter company operated the line until 1944, when it was sold to City Lines of West Virginia. That company converted the line to a bus line. (Courtesy of Davis Studio.)

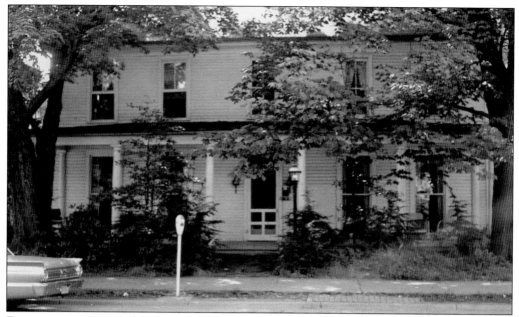

Few remnants remain of the Holt house, which sat until 2004 at 252 Main Ave. One of Weston's oldest buildings, its construction began about 1844. After several early owners, Weston physician and *Weston Republican* publisher Dr. Matthew S. Holt acquired the property in 1899. The last of the family to live in the house was Mary Holt, daughter-in-law of Dr. Holt. Ownership of the lot remains in the Holt family. (Courtesy of Davis Studio.)

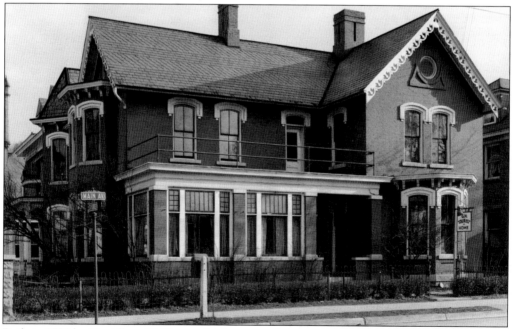

Built in 1883 by Dr. Albert H. Kunst, this home on the corner of Main Avenue and Third Street is now occupied by James Shaver, DDS. Previous occupants include Haller and Wagoner law offices. At the time this photograph was taken, it was the G. H. Tourist Home. (Photograph by Archie Ellis; courtesy of HCPD.)

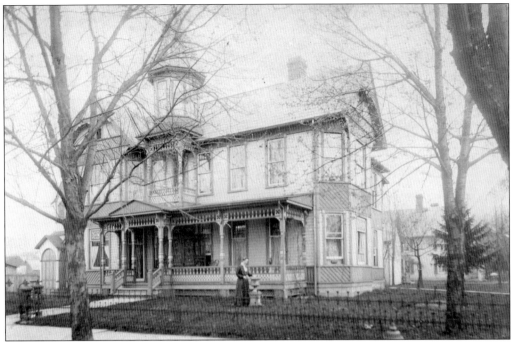

This home at the corner of Main Avenue and Third Street replaced an earlier home built by J. H. Todd. Jacob Koblegard (left), a Danish immigrant businessman and one of the owners of Ruhl-Koblegard grocery, wanted a more prestigious home for his family. He built this home in 1893–1894. It was later owned by his son, Thorne Koblegard, who remodeled it by removing the tower and adding shingles and a tile roof, thus making it resemble some homes owned by the Koblegard family in Florida. It was owned by Drs. Alexander and Emily Trefz from 1965 until 1992, when Robert and Eileen Billeter purchased the home to become the new office of the *Weston Democrat*. One prominent feature of the home's exterior that remains is the double door at the entry that has insets of colored glass. (Courtesy of Koblegard Family.)

The Weston Masonic Temple at 346 Main Ave. is one of central West Virginia's most impressive buildings. It was erected in 1917–1918 by Weston Lodge No. 10, AF&AM. Its architecture is modified neoclassical, an adaptation of ancient Greek-inspired Roman buildings, and features Doric columns. The temple is the meeting place for several Masonic organizations and their sister organization, the Order of the Eastern Star. (Photograph by Archie Ellis; courtesy of HCPD.)

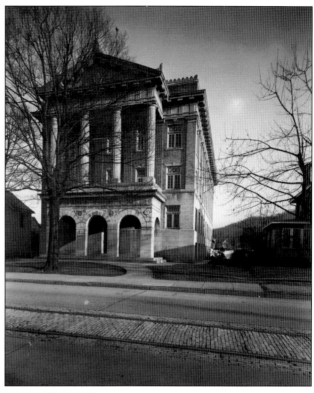

The Ice Cream Cone was a 30-foot structure located at 419 Main Ave. where the side yard of W. T. Weber Jr. is today. This popular business opened in April 1931 and operated until the early 1950s, selling not only ice cream but frozen candy bars. (Courtesy of Andrew F. Sleigh Jr., HCPD Collection.)

This 1910 Broadwater image shows the streetscape of Center Avenue looking north from in front of the courthouse. The blue sandstone wall to the right is topped with a wrought iron fence placed there in 1890. The fence was removed in 1937, when the wall was rebuilt by the Works Progress Administration. To the left can be seen the edge of the Burns Hotel. The Bennett home can be discerned behind the trees. (Courtesy of BRO.)

While historians disagree about the construction date of the original portion of the Arnold-Edwards house, it is among the oldest homes in Weston. Its history is a bit murky until its acquisition in 1851 by George Jackson Arnold. After Arnold's death in 1899, it was sold and passed to members of his family, ending with Gertrude Edwards. In 1977, the county commission acquired it and it became the West Virginia University Extension office. (Photograph by Joseph B. Gissy; courtesy of BRO.)

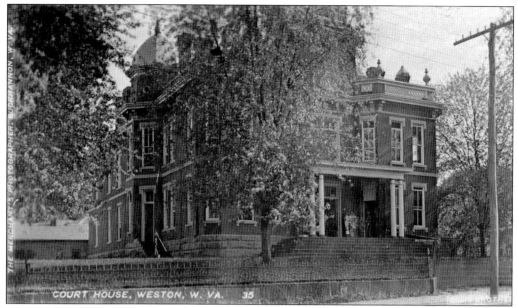

The Merchant's Photographer of Buckhannon, West Virginia, snapped this photograph of the current Lewis County Courthouse around 1912. It was completed in mid-1888 from a design by William Jepson Kitson, a local architect, stonemason, and brick contractor. Another Weston contractor, Presley Morton Hale, erected the building with a winning bid of $18,620. (Courtesy of BRO.)

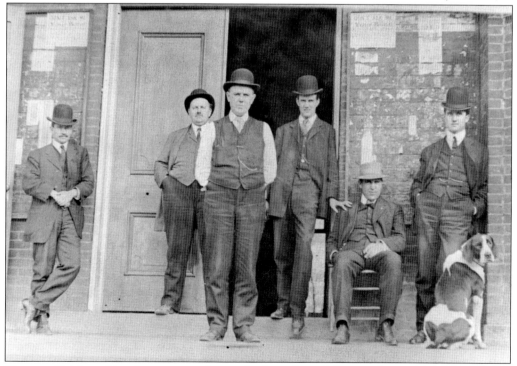

County officials and local attorneys gather at the front door of the courthouse for this photograph around 1911. Hunter Bennett Jr. was able to identify some of the men as John "Brannon" Bennett (left), William George Bennett (fourth from left), and Hunter Bennett Sr. (seated). (Courtesy of HCPD.)

Shortly after the image above was captured on July 18, 1931, the buildings were dismantled to make way for the new federal post office at Weston. The Levi Maxwell house (left) was where, in 1817, the first court to be held in Weston met. In 1878 it was owned by Jonathan M. Bennett. The Bennett Law Offices is in the center and the Burns Hotel is at right. In 1931, the rooms of the hotel were occupied by a beauty parlor. The image below, taken on the same date, shows the same block above these buildings directly across from the courthouse. (Courtesy of HCPD.)

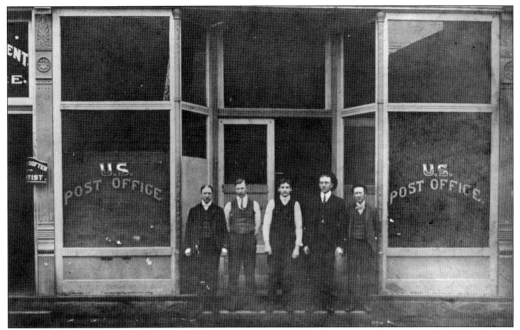

The World Building on East Second Street, where the United Bank drive-through is now, was the location for this image. It was taken sometime between 1901 and 1916, when this portion of the building was one of Weston's dozen sites that had been or would be used for the town's post office. (Courtesy of HCPD.)

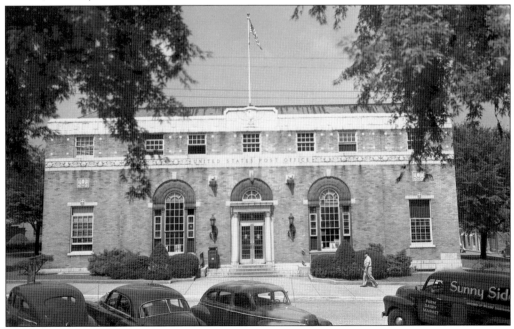

While the new federally built Weston Post Office, which opened on September 1, 1934, is important to this image, the panel truck with Sunny Side on its side catches the eye. Sunny Side Farm at Jane Lew was owned by Ray and Mary (Hacker) McWhorter. They sold dairy products from their herd of Milking Shorthorns. (Photograph by Bob Davis, courtesy of Davis Studio.)

In the far left wing of 133 Center Ave. was a branch of the Exchange Bank of Virginia, the first bank in Weston and only the fifth in western Virginia from 1853 to 1875. The bank's cashier, Robert J. McCandlish, lived in the upstairs quarters. During the Civil War, federal troops took money from the bank meant to be used to pay construction workers building the state hospital. (Photograph by Joseph B. Gissy; Courtesy of BRO.)

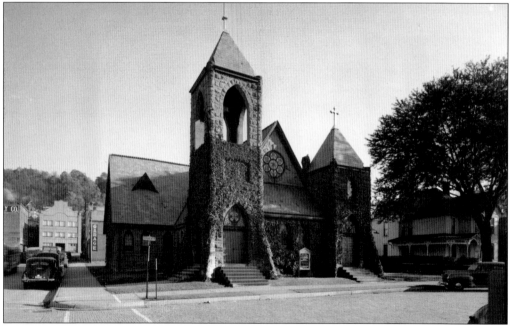

St. Paul's Episcopal Church was covered with ivy around 1940. The house to the right of the church, 146 Center Ave., was built in 1892 for James C. Forinash, furniture dealer and undertaker. On the left at the end of Second Street is the building that once was the Catholic church, but was being used by the Knights of Columbus as the Columbia Club. (Photograph by Archie Ellis; courtesy of HCPD.)

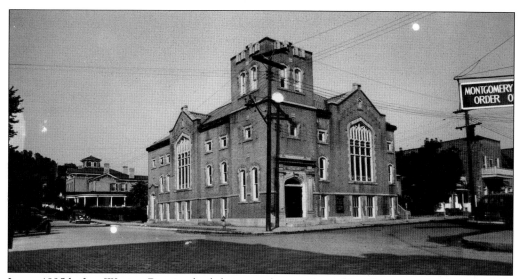

It was 1895 before Weston Baptists had their own house of worship. That year, they acquired the old St. Paul's Episcopal Church on the southwest corner of Second Street and Center Avenue. It served the Baptists until 1915, when it was razed, and this building erected. In this late-1940s image, the parsonage is hidden by the trees to the right of the church where the west wing of the building is now. (Photograph by Archie Ellis; courtesy of HCPD.)

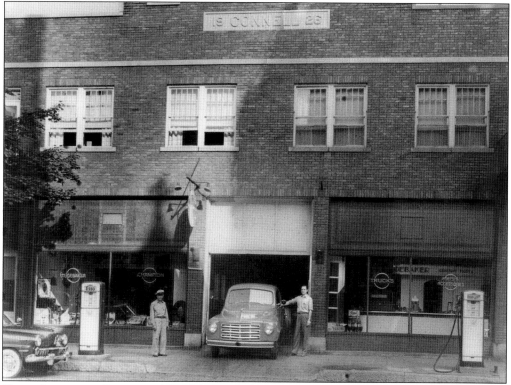

Harry Cummings Garage and Studebaker dealership was located in the Connell Building on Center Avenue, Weston. Cummings is on the right in this 1950s photograph. To the left is Walter A. Potter, the garage mechanic. (Courtesy of Jerry Burkhammer.)

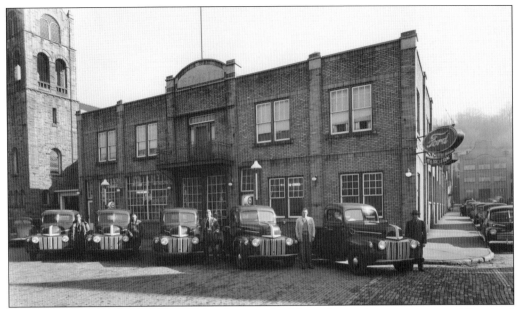

Since 1817, the location at 202 Center Ave. has morphed from a home site to temporary public school in 1868, and then back to a dwelling place. In 1918, the home was razed to make way for the Hood-Dent automobile dealership. The building photographed here in 1945 was the Lewis Motor Sales Ford dealership. In the 1960s, it was occupied by the Rogers Oil Company. St. Patrick's Catholic Church acquired the site in 1984 for a parking lot. (Photograph by Archie Ellis; courtesy of HCPD.)

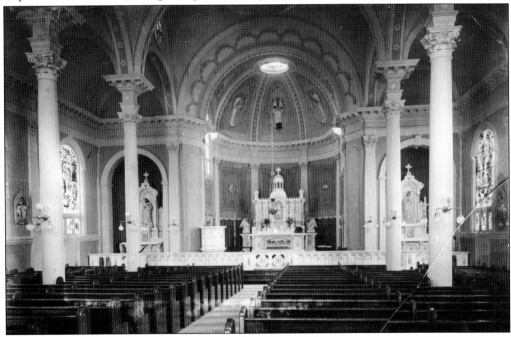

St. Patrick's Catholic Church was constructed in 1914–1915 on it present site at 212 Center Ave. This structure, with its 110-foot towers, cost $45,000 to build. Its interior, captured in this 1915 photograph, includes eight columns with Corinthian capitals, handcrafted plaster and wood ornamentation, and stained glass windows. (Photograph by Joseph B. Gissy; courtesy of HCPD.)

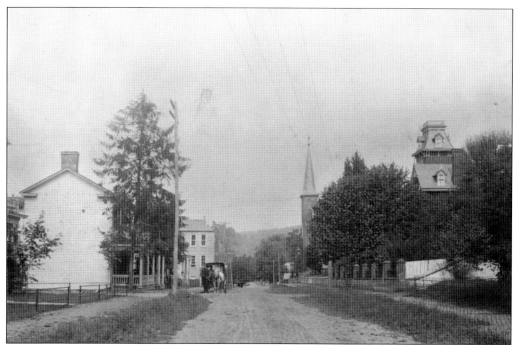

Court Avenue was unpaved when the above photograph of the lower half of the 100 block was snapped. To the left is the Samuel Hinkle home where the red brick apartment complex is now located on Court Avenue. In the distance is the early Danser Hardware building, and to its right is the spire of the second St. Patrick's Catholic Church. On the far right is the roof of the Louis Bennett home, now the public library. A slightly different later view of Court Avenue (below) shows the side yard of the Bennett Home. By this time, Court Avenue had been paved with bricks, the Catholic Church relocated, and the church spire removed. (Above photograph by Joseph B. Gissy, courtesy of BSOG; below, courtesy of HCPD.)

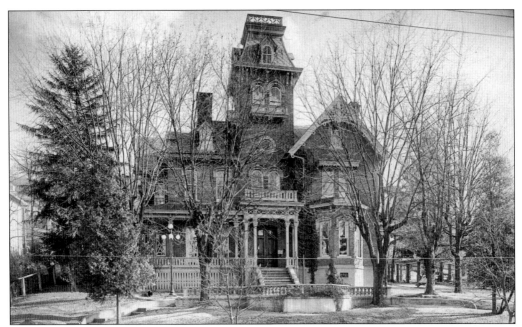

In 1874–1875, this "Riverboat Gothic" mansion on Court Avenue was built for Jonathan McCally Bennett and his family by master craftsmen who had originally come to Weston to work on the asylum. Upon Jonathan's passing in 1887, the home was inherited by his son Louis Bennett Sr., who died on August 2, 1918. Days later, his son Louis Jr., who had gone to fly for England before America entered the Great War, was shot down and killed. In just a matter of weeks of flying, he had become an ace, shooting down five German observation balloons in less than four hours. Four years later, the elder Louis' widow, Sallie, donated the home to the county as a public library and veteran's memorial in a well-attended public ceremony in memory of her fallen son, photographed below. (Above, courtesy of BRO; below, courtesy of Louis Bennett Public Library.)

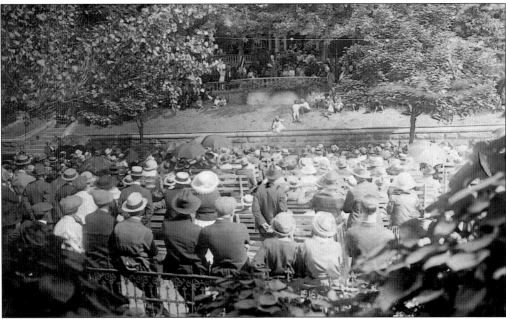

World War I flying ace 2nd Lt. Louis Bennett Jr. poses in this photograph in front of his plane. Trained as a pilot in the United States, Bennett volunteered and was commissioned in the Royal Air Force in 1918. He was shot down and killed at the age of 24 in Provin, France, while attacking a German observation balloon. (Courtesy of Davis Studio.)

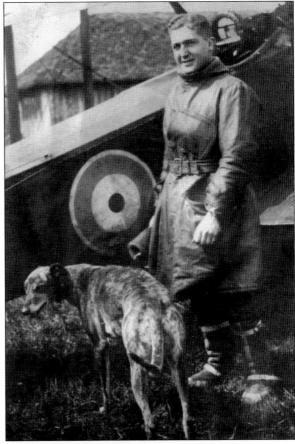

This group of Lewis County men, known as the Lieutenant Bennett Society, gathered at the gravesite of Louis Bennett Jr. in Machpelah Cemetery, Weston, with his mother, Sallie Maxwell Bennett. The occasion was the 16th anniversary of his death on August 24, 1918. (Courtesy of Minter Ralston III.)

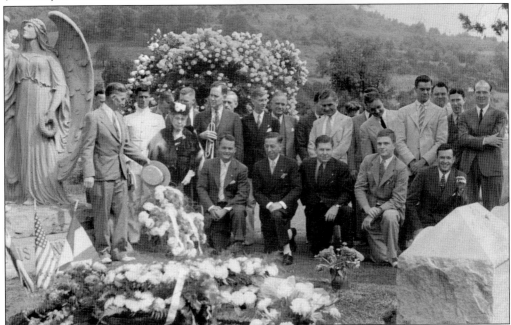

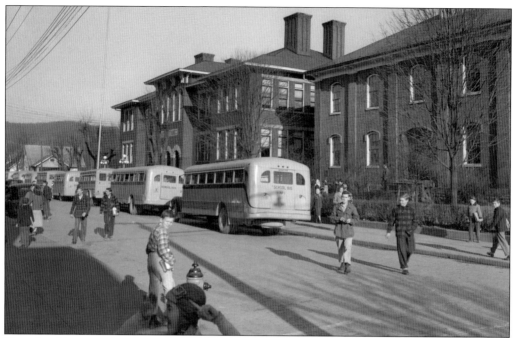

Five school buses are lined up in front of the old Weston High School (left) in this 1951 photograph. The building on the right was the original public school building in the town. It was built in 1872 and continued to serve as an educational building until 1994, in its later days as part of the Robert L. Bland Middle School. (Photograph by Archie Ellis; courtesy of HCPD.)

The ground underneath what is now Central Grade School was once very swampy. Central was built on the site in 1926. It was vacated when Peterson-Central Elementary School was constructed on Berlin Road in 1999. The building then became the offices for the Lewis County Board of Education. (Photograph by Bob Davis; Courtesy of Davis Studio.)

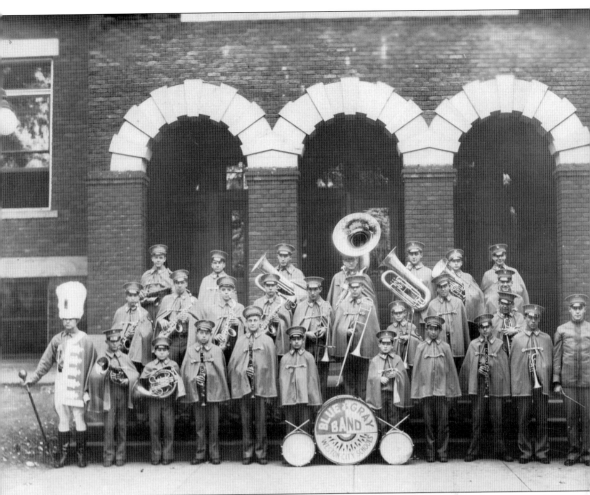

The Weston City Schools Blue and Gray Band posed for this early picture on the front steps of the high school. Pictured from left to right are (first row) drum major Kent Kessler, unidentified, Ray Goodwin, Glen Koon, Harold Tomasko, unidentified, John Collins, Dennis Norman, Ernie Salvino, director Earl Davis, and Charles "Dud" Holt; (second row) unidentified, Gene Chalfont, Bill Woofter, unidentified, Glenn Warner, Hugh Fultz, Tom Curry (the little guy), Dave Berry, Dominic Tucci, and behind Tucci, Ernie Malone; (third row) Willard Bodkin, unidentified, Ray Squires, Charles Gum, Glen "Radio" Peters, George Bland, and Ruskin Bland. (Courtesy of BRO.)

On the right in this 1910 Broadwater image looking up East First Street from Main Avenue is the Whelan Store, now known as the KISS Community Center. Local historians believe that here, at 114 First St., once stood the cabin home of Weston's first resident, Henry Flesher. Andrew Francis Whelan Sr. built his store here in 1886, replacing a former frame store on Main Avenue that had burned in a business section fire earlier in the year. (Courtesy of BRO.)

This c. 1912 East First Street image is farther east than the above photograph. On the left side of the picture is the corner of the Colonial Revival home built by Porter Arnold in 1907–1908. Across the street at 236 First St. is the home constructed by Judge John Brannon in 1853. Behind that home is a white, two-story brick structure in which it is believed the Brannons housed their household slaves. (Courtesy of BRO.)

The initial foundry operations for what became the Danser Hardware and Manufacturing Company were first located where the Danser Hardware Building stands today on the northwest corner of Court Avenue and East Second Street (237–242 East Second St.). In the second half of 1906, the foundry was moved to the site pictured below, which was north of West Second Street, between the present municipal building and Depot Avenue. The foundry was photographed in September 1910. In 1924, the three-story brick building was built on the former foundry site. It served the firm's wholesale hardware business, which had been located across the street in the Fuccy building (right) for 20 years. The business closed in 1982. (Right, photograph by Joseph B. Gissy; below, photograph by G. H. Broadwater; Courtesy of BRO.)

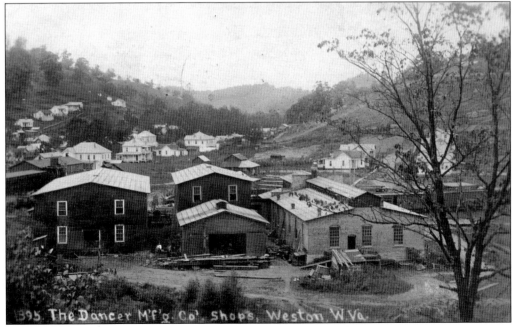

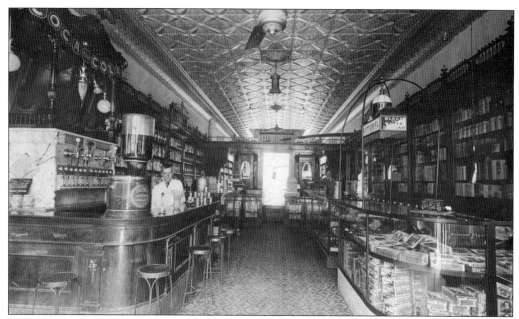

In 1907, Roy Bird Cook, a native of Roanoke in Lewis County and a recent graduate of the West Virginia University School of Pharmacy, joined Ralston's Drug Store as a partner. By this time, the store had moved to the east side of Main Avenue and occupied the address of 172 Main Ave. When Cook moved to Charleston, the store reverted to a sole proprietorship. Cook would eventually become a noted authority on Lewis County history. (Courtesy of Minter Ralston III.)

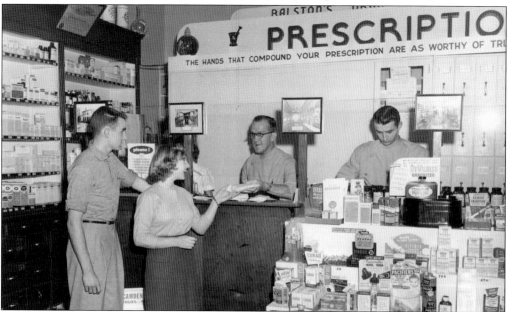

The Ralston Pharmacy was in business for 135 years. It had two different locations on Main Avenue and then on Second Street before closing in 2002. The store passed from Er Ralston to his son Minter, then to Minter Jr. and lastly to Minter III. In this image, Minter Ralston Jr. hands a prescription to Carolyn Fisher while Bill Shaw looks on. Minter Ralston III is at the far right. (Courtesy of Minter Ralston III.)

Prior to 1920, Weston had no hospital. In that year, General Hospital (above) was established by Drs. Thomas F. Law and Aubrey F. Lawson in an apartment house on Third Street. The next year, Drs. Edward T. W. Hall and William H. Greene opened City Hospital (below) at 501 Main Ave. In 1938, Drs. Ralph M. Fisher and Edwin A. Trinkle acquired City Hospital. In 1958, they sold it to Stonewall Jackson Memorial Hospital (SJMH). Meanwhile, in 1948, Dr. Alexander Trefz purchased General Hospital and renamed it General Osteopathic Hospital. In 1969, he joined the staff at SJMH and converted the old hospital into offices for himself and his wife, Dr. Emily Trefz. Upon the passing of the couple, the hospital became apartments, which have since been condemned. (Above, photograph by Archie Ellis, courtesy of HCPD; below, photograph by Bob Davis, courtesy Davis Studio.)

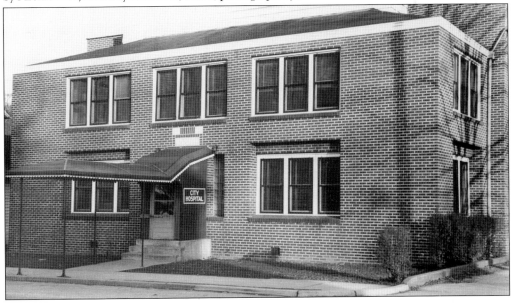

Hornbeck and Vigor operated the Ford dealership in this building at the corner of High and Third Streets. It was later owned by the county board of education, which had offices on the second and third floors. After the new Peterson-Central Elementary School was built in 1999, the board moved its offices to the old Central School and sold this building. It is now privately owned. (Photograph by Archie Ellis; courtesy of HCPD.)

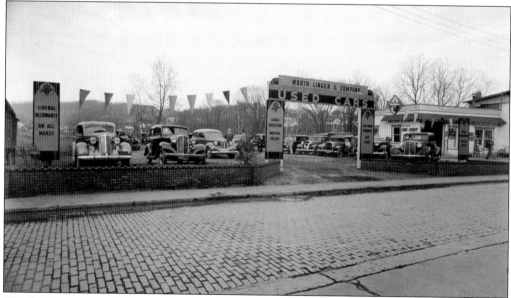

Worth Linger operated this used car lot at 373 East Third St., where H&M Motors is now located. For a time, Linger also operated a Hudson-Essex automobile dealership at the same location. (Photograph by Archie Ellis; courtesy of HCPD.)

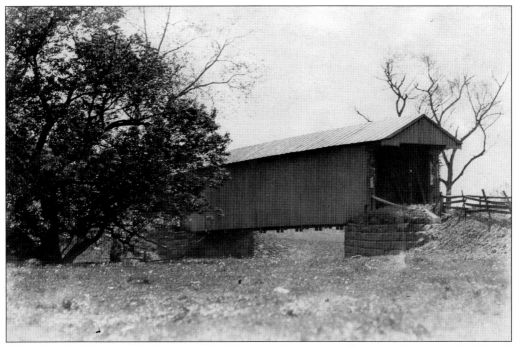
The Stone Coal covered bridge carried the Staunton Turnpike traffic across the Stone Coal Creek in the vicinity of today's Hardees. It was built by famed covered bridge builder Lemuel Chenoweth of Philippi, whose bridge was judged the strongest of all in an 1840s contest in Richmond. This bridge was destroyed by the 1950 flood. (Courtesy of WVRHC.)

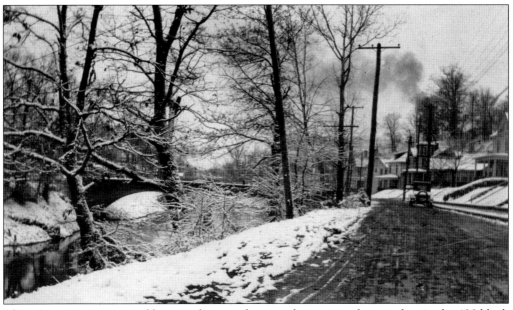
This winter scene, captured by an unknown photographer at an unknown date in the 400 block of River Avenue, shows the Fourth Street Bridge in the distance. Note that River Avenue is unpaved. (Courtesy of BRO.)

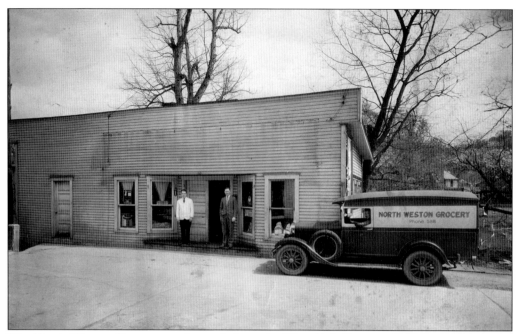

The North Weston Grocery was located along the West Fork River at 500 North River Ave., according to Polk's Weston City Directory of 1928–1929. It was owned by Edward McKinley. The store included a post office with mailboxes. (Photograph by Archie Ellis; courtesy of Jerry Burkhammer.)

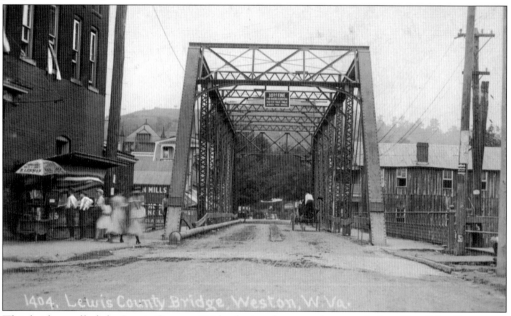

This bridge, called the Lewis County Bridge by its photographer, carried traffic of the Staunton-Parkersburg Turnpike (U.S. 33-119 West) across the West Fork River. This image was taken from the western end of the bridge. The brick building immediately to the left was the Monticello Hotel. At the opposite end of the bridge, the Bailey House, the inn and favored town meeting place, is visible from the rear. (Photograph by G. H. Broadwater; courtesy of BRO.)

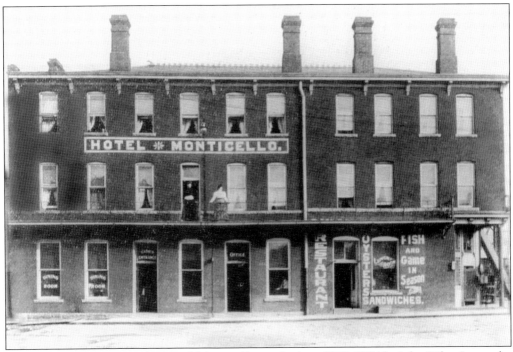

Fronting on River Street, the Hotel Monticello was built in 1903–1904 by John Riley. It was the newest hotel in town and the first to have fire escapes. Although located just across the street from the train depot, the establishment and its eatery failed to attract as many visitors as the popular Bailey House or the fancier Camden Hotel, both located two blocks away. It was later known as the Westoner Hotel. (Photograph by Joseph B. Gissy; courtesy of Davis Studio.)

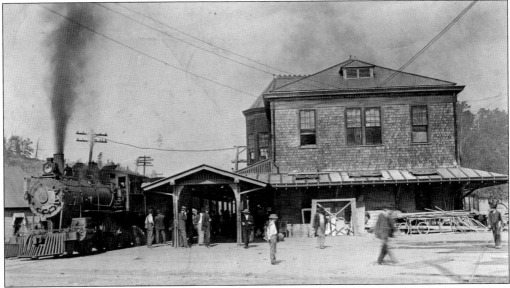

The train depot located on West Second Street, completed in 1892, originally served as a depot for the West Virginia and Pittsburgh Railroad and was a passenger station as well as a freight station for the Baltimore and Ohio Railroad beginning in the late 1800s. Today the structure is the Weston Municipal Building. (Courtesy of John Gissy).

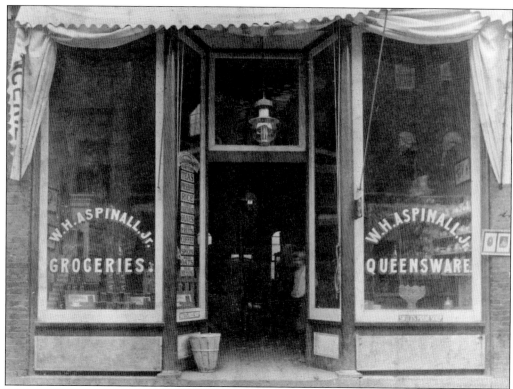

William H. Aspinall Jr. operated a grocery story on West Second Street. A string of signs near the entrance to the store advises customers of some of his wares, including today's highly collectable Queensware. Examples of that pottery can be seen on the shelves to the right in the lower picture. Aspinall stands in the back of the store beside the potbelly stove. (Photographs by Joseph B. Gissy; courtesy of HCPD.)

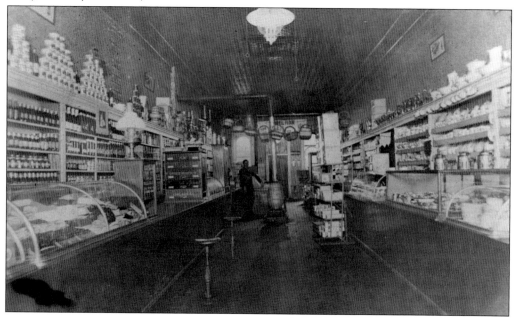

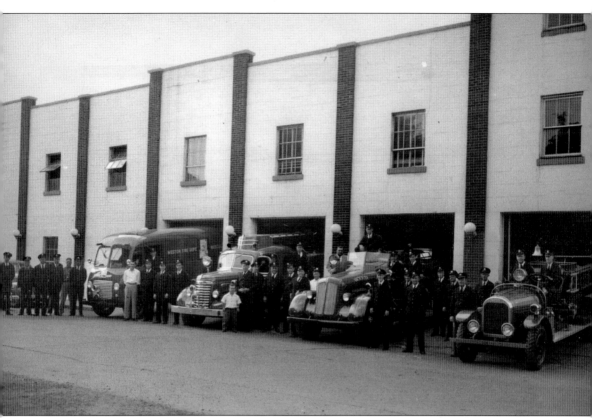

This photograph of the Weston Fire Department was taken in the early 1950s when it was located on Water Street. From left to right are Tommy Hinzman, Basil Sterman, Charlie Davis, Ed Mullady, ? McLaughlin, Junior Davis, Elza Oldaker (driver), ? Snyder, ? Marsh, Chuck Eckes, Jock Conley, Shorty Townsend, Buck Cunningham, Junior Weston, E. J. Turner, Ted Ellis, Dave Beachler (on the sideboard), Harry Feagans (driver), Charlie Ballard (on the sideboard), Dale White, Ed Blair (driver) Cecil Fisher (behind driver), Jack Hall (in front of driver), ? Lough (left front of driver), Rod Lefever (by truck), Red Stalnaker, Earl Johnson, Lynn Brown (passenger), and Glenn Brown (driver). (Photograph by Archie Ellis; courtesy of HCPD.)

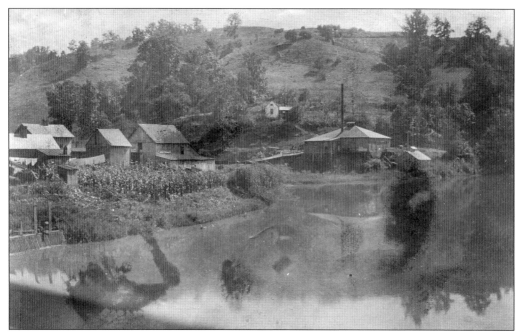

The old dam that can still be seen near First Street in the West Fork River is visible in the foreground of this picture of Arnold's Livery Stable (buildings on the left) and "Weston's first electric light plant" (far right). J. S. Mitchell was the light plant superintendent. This image was provided by Roy Bird Cook, early-20th century historian of Lewis County. (Courtesy of WVRHC.)

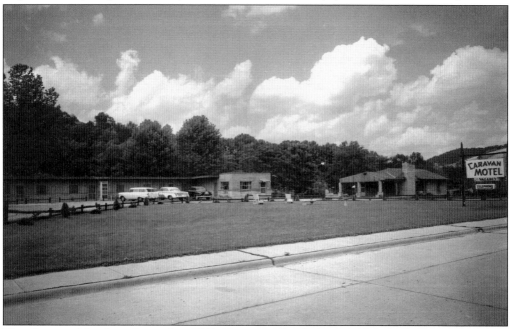

The Caravan Motel was located on U.S. 19 just south of Weston. It was built in 1956 by Merle and Francis Crawford. They built the adjoining restaurant and it opened on August 8, 1962. Their daughter and son-in-law, Janet and Nick Bakas, operated the restaurant. They later divorced and Janet operated the restaurant by herself. (Photograph by Bob Davis, courtesy of Davis Studio.)

Three
WESTON HOSPITAL

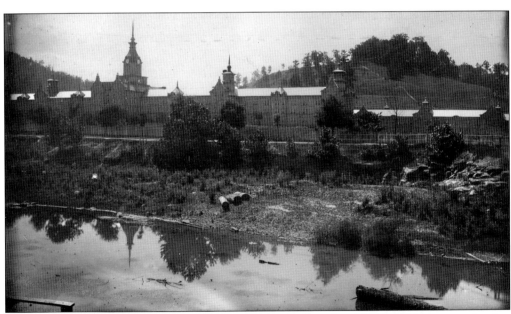

This photograph of the asylum was recorded at noon on Thursday, July 10, 1884, just months after its construction was completed. It is one of the oldest extant images of this massive building. Note the stone in the banks along the West Fork River. These are the remnants of the blue sandstone quarried from the riverbank to build the hospital. (Photograph by Thomas and Walter Biscoe; courtesy of WVRHC.)

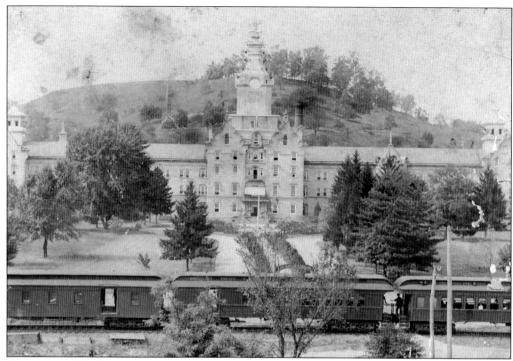

This image of the historic Weston State Hospital was probably captured around 1910. Other pictures of the decade show similar palm trees around the front door. Note the canopy covering the balcony on the second floor in the main section. A close looks reveals the middle train car as being a "railway post office." (Photograph by Yorty's Studio, Weston, West Virginia; Courtesy of WD.)

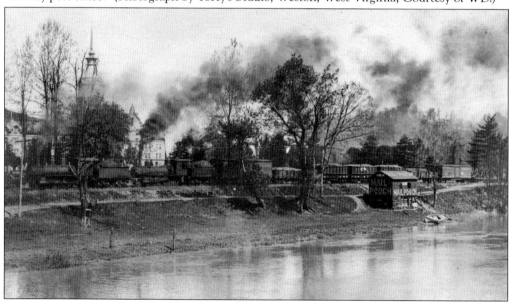

Local photographer Joseph B. Gissy captured this unusual image of loaded train cars being pulled past the West Virginia Hospital for the Insane by a puffing engine in 1912. A building with a Mail Pouch tobacco ad and a docked rowboat hugs the West Fork River bank and adds a nostalgic touch to the scene. (Courtesy of John Gissy.)

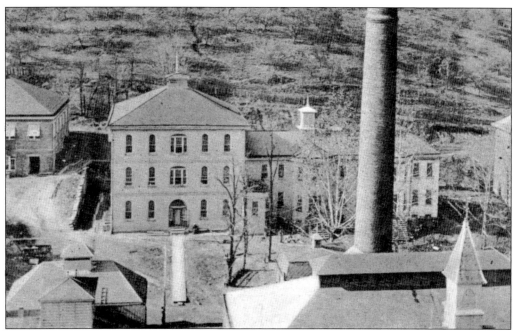

The building in the center was built specifically to house non-whites at the West Virginia Asylum for the Insane. This image was captured about 1908 from the central tower area of the main building. The smoke stack is for the boiler room, which provided heat for the entire complex. (Courtesy of BRO.)

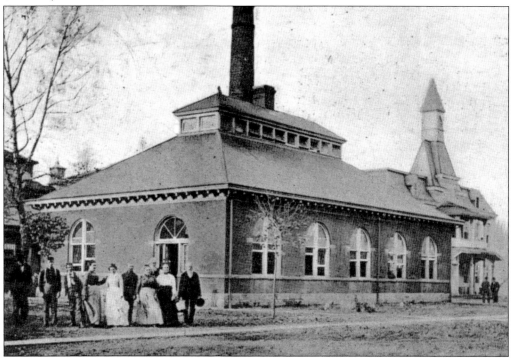

This is the kitchen of the asylum as it appeared around 1908. Much of the food cooked in this kitchen was raised on the hospital farm or was purchased from area farmers. (Courtesy of BRO.)

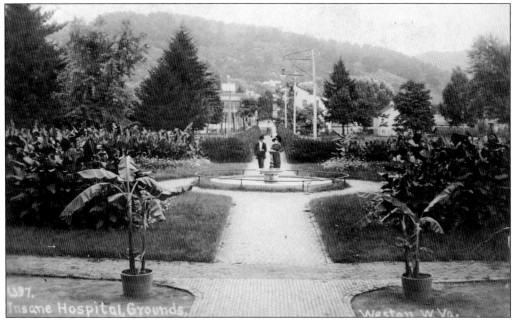

This view from the front portico of the West Virginia Hospital for the Insane was captured by G. H. Broadwater when he was in town on September 10, 1910. Potted banana trees set off the entrance, while the canna plants around the fountain and the privet hedges leading to the front gate give the hospital a sense of privacy. (Courtesy of BRO.)

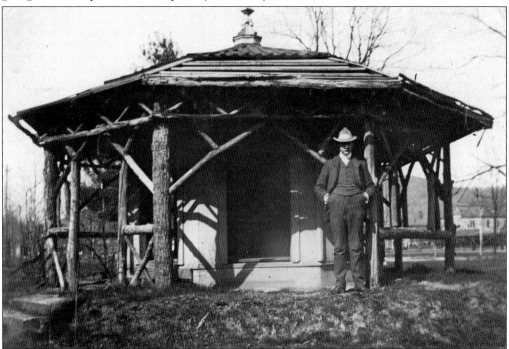

A number of summerhouses or gazebos were located on the state asylum property. They provided shady locations for patients to enjoy the outdoors. This one was in the southern end of the front yard. Its location can be seen in the image on the cover of this book. (Courtesy of WD.)

In the early 1900s, a second set of gates for entry to the West Virginia Insane Asylum was located on the corner of West Second Street and River Avenue directly across from the train depot (now the Weston Municipal Building). While the date of the picture above is uncertain, the lower one was taken on September 10, 1910, when G.H. Broadwater visited Weston. Note the circus poster on the telephone pole. It undoubtedly was advertising the Frank A. Robbins Circus, which was in town on that date. Note the bed of cannas just inside the gate. (Above, courtesy of WD; below, courtesy of BRO.)

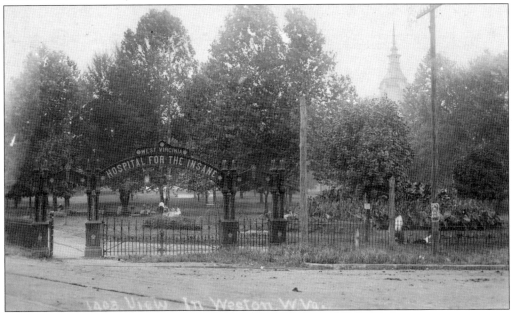

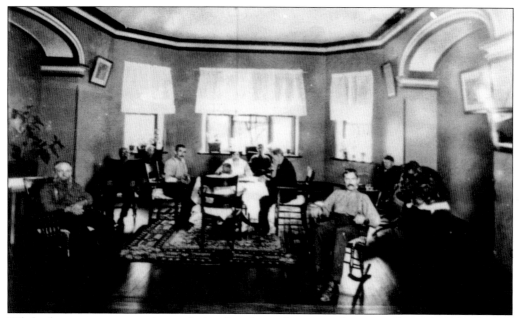

While there were some patients admitted to the asylum over the years who required restraints to keep them from injuring themselves or others, this was not always the case. Because there were few medicines to treat the many people who suffered from depression, dementia, and similar illnesses, most of them were kept in a safe environment. These patients frequently socialized in areas of the hospital furnished with a homelike atmosphere. (Courtesy of HCPD.)

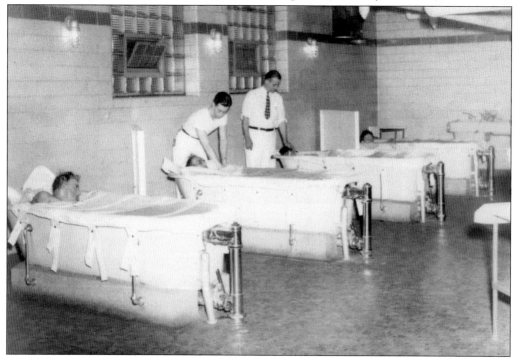

One of the means of calming patients at the Weston State Hospital in the mid 20th century was water therapy. Sometimes ice water was used and other times warm water. (Courtesy of HCPD.)

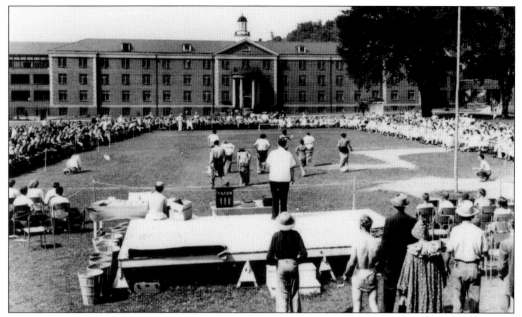

A number of patients at the asylum had the opportunity to participate in outdoor activities like the sack races shown here on the expansive grounds of the hospital. In the background is one of the newer buildings in the complex built in 1946 and commonly referred to as the TB (tuberculosis) Ward. Like most of the wards and buildings on the property, it was used for different groups of patients at different times. (Photograph by Archie Ellis; courtesy of HCPD.)

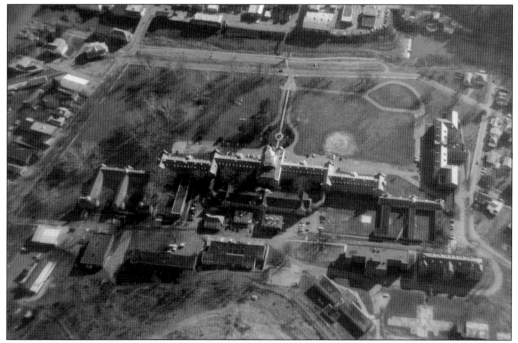

This aerial image of the asylum helps the viewer understand the description of the hospital being "eagle like," with the central tower being the eagle's head. This view focuses on the back of the building, an area seldom seen by visitors to Weston. (Courtesy of WD.)

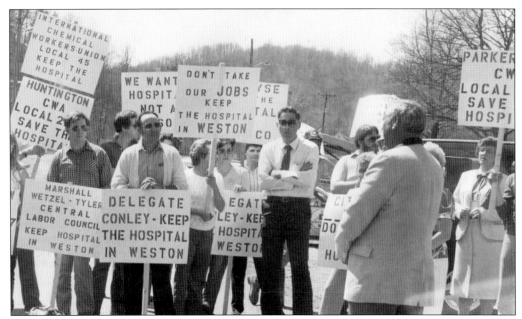

In January 1985, Gov. Arch Moore proposed to convert the asylum into a penal institution and build a new mental health complex elsewhere in north-central West Virginia. His plan met with resistance from the state legislature, state hospital employees, and Lewis County citizens. State Sen. William R. Sharpe Jr., speaking here to protesters on April 2, 1986, successfully fought to keep it in Weston. The new hospital would later be named for him. (Courtesy of WD.)

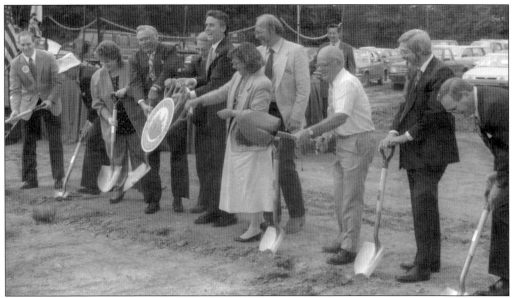

Although there was an ongoing court battle about the location of a new mental health facility, the Department of Health and Human Resources held a ground-breaking at the site now known as William R. Sharpe Jr. Hospital on September 7, 1990. Construction began on July 7, 1992. Pictured from left to right are Jay Wolfe, Delegate Robert Conley, unknown, Sen. William R. Sharpe Jr., Gov. Gaston Caperton, Rein Valdov, unknown, County Commissioner Gerald Stalnaker, unknown, and Lou Pelegrin. (Courtesy of WD.)

Four
LEWIS COUNTY COMMUNITIES

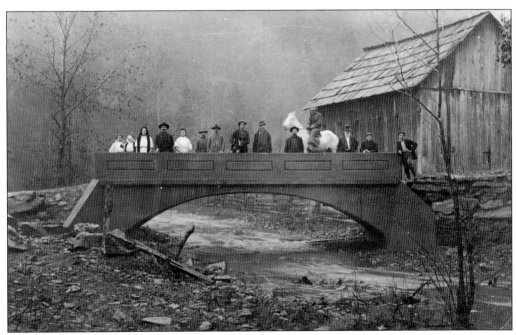

This image depicts the bridge at Bablin, probably recently constructed at the time this photograph was taken. In this picture, it appears residents have gathered on the bridge, which remains standing today. Bablin is located in southern Lewis County between Duffy and Wildcat. (Courtesy of Don Henderson.)

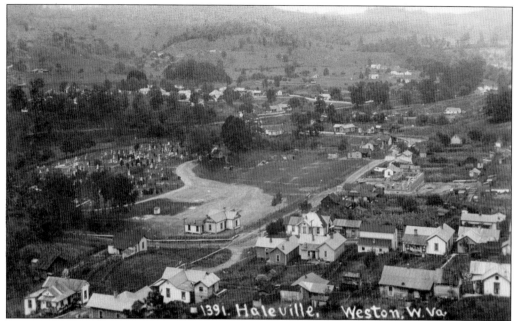

Clearly visible in this 1910 photograph overlooking Haleville is the Machpelah Cemetery and, in the right center, the ongoing construction of Haleville School. In the upper half of the photograph are homes along Mid Avenue, a part of the Shadybrook community. (Photograph by G. H. Broadwater, Courtesy of BRO.)

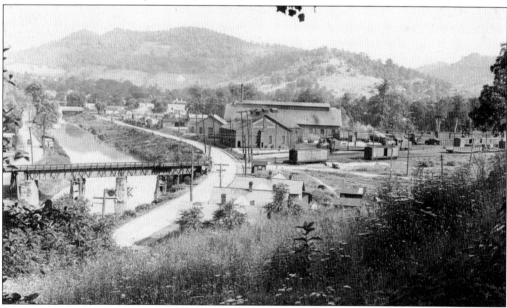

This photograph taken from Shadybrook Hill highlights what was then the B&O Railroad roundhouse and shops. Today the buildings house the Lewis County school bus garage and advertise the slogan "Safety First." When this image was captured around 1920, the message on the building's end was "Above Everything Else Weston Shops." Note the railroad trestle across the West Fork River on the left and the streetcar tracks along the road immediately in front of the roundhouse. (Courtesy of Lawrence H. Chapman.)

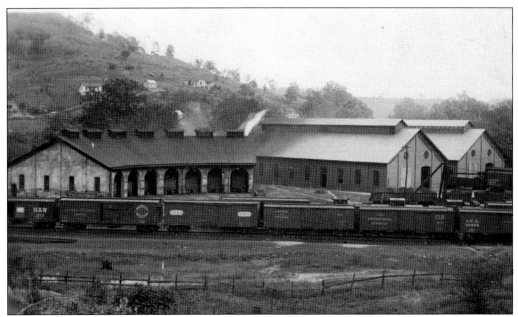

With the coming of the narrow gauge railroad to Lewis County in 1879, and later the standard gauge railroad, the county was opened to outside commerce and industrialization. This 1910 photograph shows the B&O Railroad roundhouse and shops. The last train ran in Weston in 1989, and today the tracks have been removed. CSX still runs trains through southern Lewis County. (Photograph by G. H. Broadwater, courtesy of BRO.)

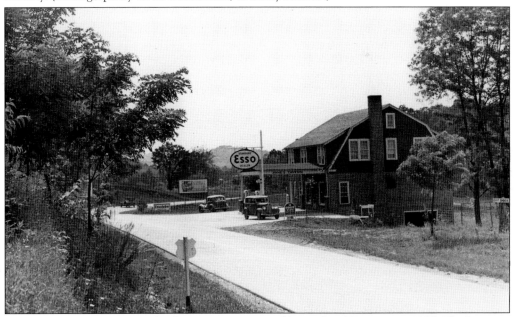

Jones Esso on Route 19 north of Weston was opened by Richard E. Jones in 1935. The business sold gas and groceries in addition to renting tourist cabins, located to the right of the station. In the mid-1950s to early 1970s, the station was rented. With the opening of I-79 and the diversion of traffic to the new highway, the business closed. Today the dilapidated structure stands in the curve near Maxwell's Run. (Photograph by Archie Ellis; courtesy of HCPD.)

Members of the Joseph H. Clifton family are pictured on the porch of the house built by Cummins Jackson, uncle of "Stonewall" Jackson, between 1843 and 1849. Clifton purchased the house in 1886 and remodeled it, adding a third chimney, new windows and siding, and the porch. Despite popular belief, the famous general never lived in the house, having left for West Point the year construction began. (Courtesy of Betty Reed.)

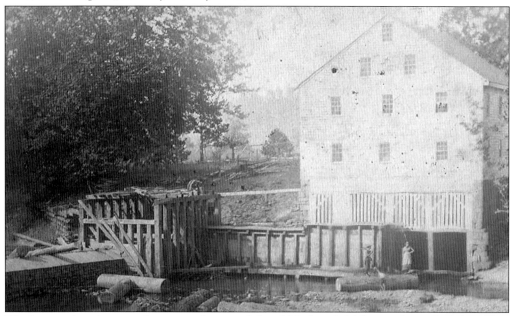

The logs in this photograph witness the use of the old Jackson's Mill as a place where logs were sawn into dressed lumber. The people below the mill are believed to be members of the Joseph H. Clifton family, who purchased the property in 1886 after the Clifton Woolen Mill in Weston burned a year or so earlier. The original of this image bears the handwritten identification of Ella Clifton, a J. H. Clifton daughter. (Courtesy of Betty Reed.)

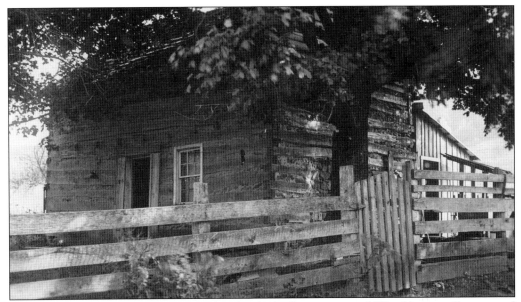

The McWhorter Cabin is among the oldest family dwellings in central West Virginia. Constructed in 1793 at West's Fort (now Jane Lew), it served as church, school, post office, and community center, as well as a dwelling place for Henry McWhorter and family. This photograph was taken in 1910 when the cabin was in its original location. In 1927, it was moved to Jackson's Mill. (Photograph by G. H. Broadwater, courtesy of Dick Duez.)

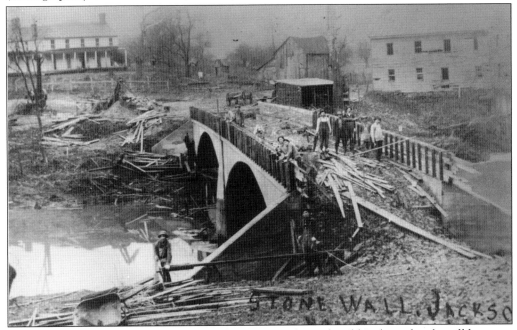

This bridge was built across the West Fork River just above the old Jackson family mill between 1910 and 1915. Prior to its construction, the river could only be forded at a location about 50 feet north of the mill. The Jackson home is in the background. The mill and adjacent property were acquired by the state of West Virginia in 1924 and are now under the supervision of West Virginia University. (Courtesy of BSOG.)

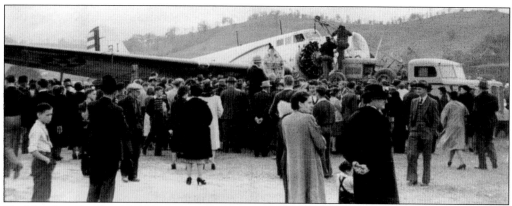

On Monday, October 23, 1938, a B-18 bomber made an emergency landing at the Jackson's Mill airfield because of a frozen motor. The pilots had just ordered the 15 men aboard to bail out when they discovered the new airfield, which was not on their maps. Thousands toured the craft before it was repaired and took off for its Michigan destination on October 31. (Courtesy of WD.)

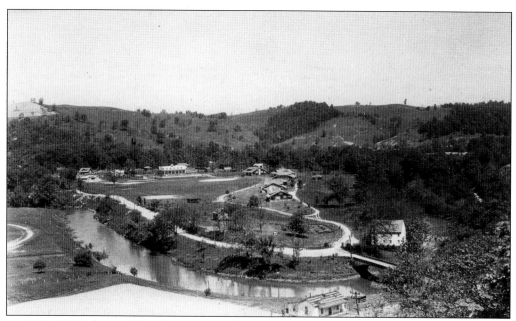

In 1920, 4-H leaders in West Virginia settled upon Jackson's Mill as their central meeting place, and the first camp was held in 1921. Originally only 5 acres donated by Monongahela Power Company, the camp is now over 500 acres. This bird's-eye view of the Jackson's Mill campus predates when the channel of the West Fork River was diverted. (Courtesy of BRO.)

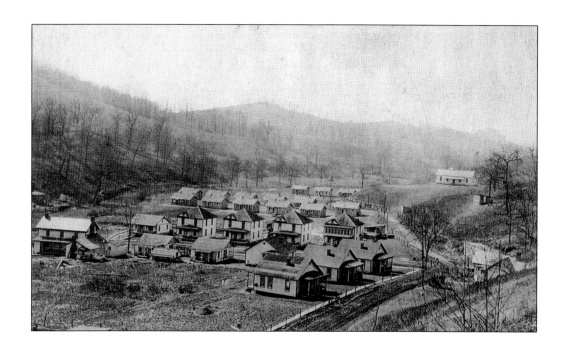

Kennedy Station (below) was built by the Reserve Gas Company as their compression station in 1911–1912. Most of the homes for company employees as well as the school on the hill above the station were built between 1913 and 1919 (above). The company combined with others over the years and became the consortium Consolidated Natural Gas. Beginning in 1959, a new compression plant was built and the remaining homes were sold to employees and relocated elsewhere. (Above, courtesy of Ed Lester; below, courtesy of BRO.)

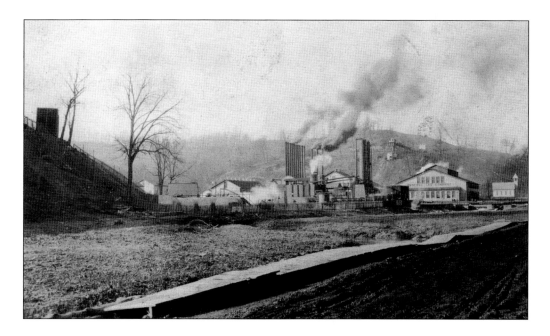

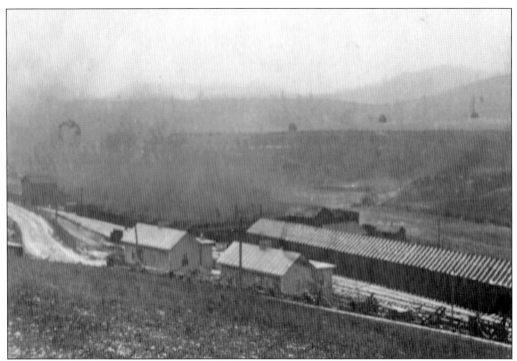
Oscar Nelson was the superintendent of the Raven Carbon Black Company near Jane Lew. The plant closed and the property was returned to W. E. McWhorter on March 24, 1915. The house in the front right of the photograph is the same house as in the bottom front of the photograph below. (Courtesy of John Saeler.)

The Raven Carbon Black Company (above photograph) once was located in the bottom along West Run south of Jane Lew on Route 19. The home on the hill above the plant was the W. E. McWhorter home. It now belongs to John Saeler. The route of the road had not yet been changed in this photograph. (Photograph by Joseph B. Gissy; Courtesy of John Saeler.)

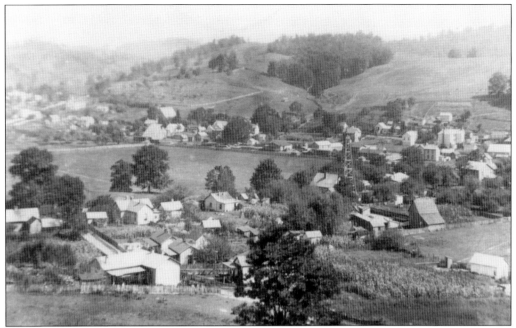

Photographer G. H. Broadwater was standing on the hill behind Hall Addition when he captured this image of Jane Lew in September 1910. Most of the buildings in the foreground are extant. The buildings running parallel through the middle of the image are those along Main Street. (Courtesy of HCPD.)

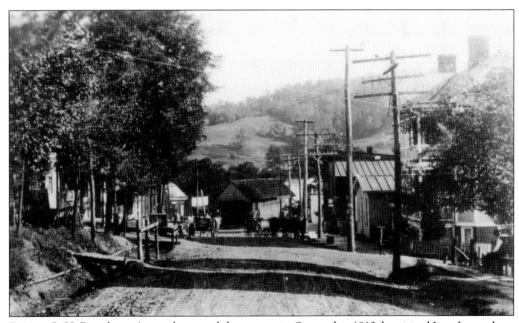

During G. H. Broadwater's travels around the county in September 1910, he visited Jane Lew, where he captured this image of Main Street looking south. The covered bridge across Hacker's Creek is clearly visible in the center of this photograph. A sign advertising the circus that was visiting Weston at the time is visible on the second telephone pole from the right. (Courtesy of HCPD.)

Walter Neely Sr. stands on the right in front of his store in Jane Lew. He purchased what was then called Jane Lew Hardware in 1912 from Raymond Westfall. It remained in the family until 1967, when Walter Neely Jr. closed it. The structure still stands on Depot Street and is the present location of Auto Roundup. (Courtesy of BRO.)

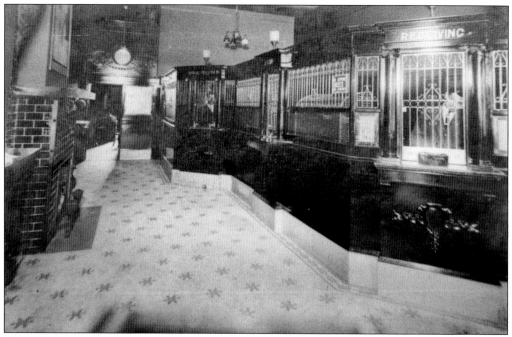

The interior of the Bank of Jane Lew, founded in 1903, is shown in this photograph. The bank was located at what later became the Standard Gas Company office (6167 Main St.). The bank was one of two in a thriving Jane Lew. People's Bank, founded in 1911, was located on the corner of Main Street and Depot Street and is now the Jane Lew town hall. (Courtesy of HCPD.)

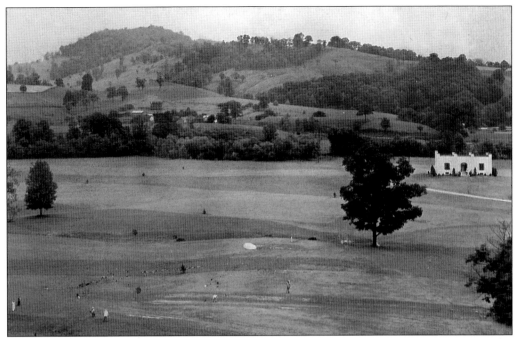

Thorne Koblegard built a public golf course on what had been a part of the Christian Straley farm at Jane Lew. The eastern boundary of the course was delineated by Hacker's Creek, hidden behind the near line of trees in this photograph. Today this area encompasses the Lewis County Industrial Park. (Photograph by Archie Ellis, courtesy of HCPD.)

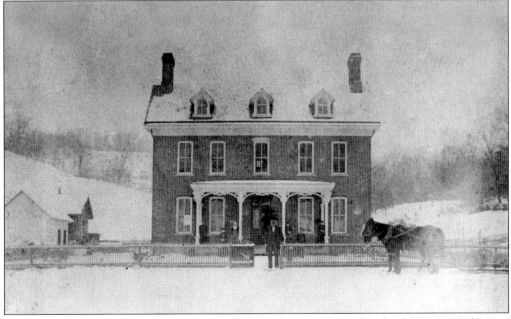

Judge Noah Life (1824–1919) stands proudly with his family in front of his brick home on Life's Run near Jane Lew. The house was considered a mansion in its heyday and even now draws questions and comments from passersby as they view it just south of mile marker 103 southbound on I-79. Today the house is owned by the Hicks family. (Courtesy of Archie Ell Bennett.)

In this c. 1904 photograph, a group has gathered outside the Broad Run Baptist Church, the second oldest congregation in the county. This church was organized in 1804, and this is the fourth structure to serve as the church. This building was dedicated on Sunday, September 18, 1887. (Courtesy of HCPD.)

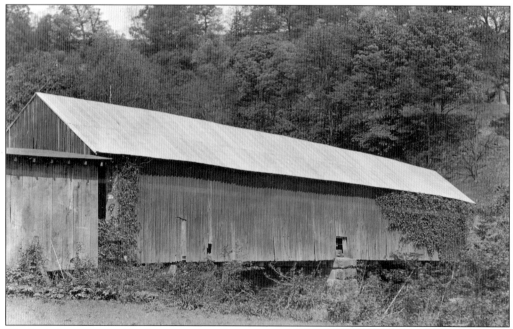
The Lightburn covered bridge carried traffic across the West Fork River in the community of the same name. Benjamin Lightburn established his mill there around 1830, when he relocated from Westmoreland County, Pennsylvania. His son, Joseph, was a Baptist minister as well as a Union general in the Civil War. (Courtesy of WVRHC.)

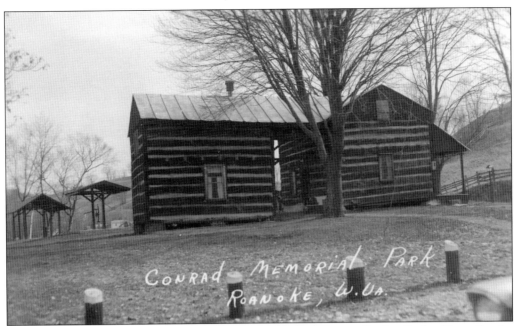

The Conrad cabin was built before 1860 alongside the Weston-Gauley Bridge Turnpike. Its location in the wilderness made it a stopping place for travelers, especially during the Civil War, when troops would bivouac there for short periods of time. In 1961, Mary Conrad, the last of the family to be born in the house, donated it to the state of West Virginia as a roadside park and meeting place for the Roanoke Farm Women's Club. (Courtesy of BRO.)

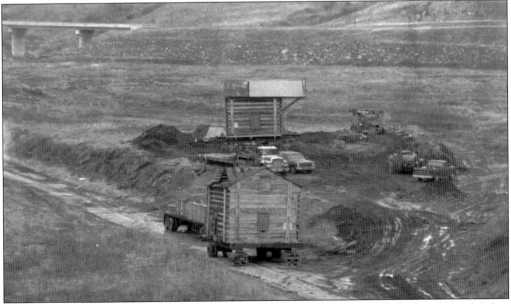

With the building of the Stonewall Jackson Dam in the 1980s, the historical Mary Conrad Cabin was moved from Roanoke, where it would be underwater, to a park-like setting on the water's edge. The cabin was frequently vandalized in its new location. In 1993, it was moved once again, this time to West Virginia University–Jackson's Mill where it now serves as an anchor for the historic area. (Courtesy of WD).

Although he was a pharmacist by trade, Roy Bird Cook was a noted local historian by avocation. In this c. 1900 photograph, he pauses in front of the Quiet Dell School, which was once in the Roanoke community. (Courtesy of WVRHC.)

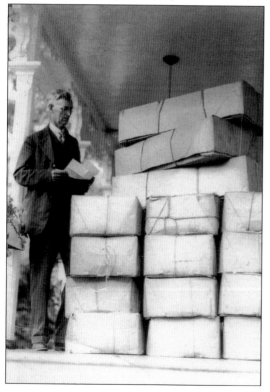

Charles G. Kerns (1884–1959) operated a fur and jewelry business, Kerns Fur Farm, at his home at Roanoke from the mid-1940s to 1959. His son, John Paul Kerns, then operated the business until 1966. Furs were delivered from Cohen Brothers Furrier in New York City. In this picture, Kerns inspects a shipment of furs on his front porch. People from throughout West Virginia came to "the fur room" to purchase New York's finest. (Courtesy of Charles Kerns.)

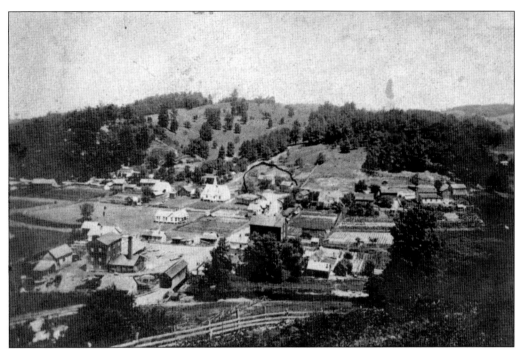

What today is the little community of Berlin in northeastern Lewis County was once a bustling village with a service station, general store, a hotel, and a gristmill. Today only homes and the Methodist church remain. (Courtesy of BRO.)

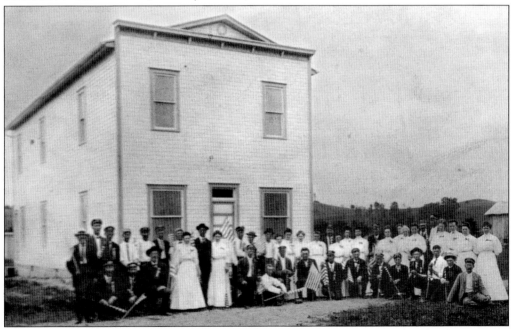

After the Civil War, farm families across the country began to band together for the common economic and political well-being. Many of these families belonged to the National Grange, a fraternal organization for American farmers. They erected buildings called Grange Halls as their meeting places. This is the Berlin Grange Hall with some of its members. (Courtesy of HCPD.)

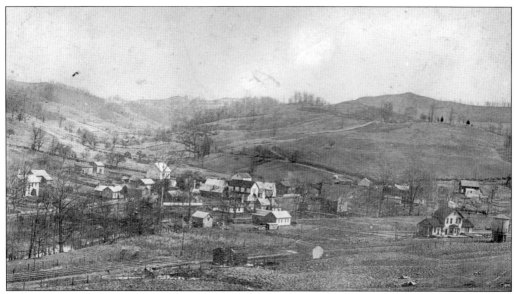
At the far right in this bird's-eye view of Crawford is a watering tower used to fill the steam engines that passed through on the railroad tracks in the foreground. The train station is visible in the right-hand corner as well. (Courtesy of Dick Duez.)

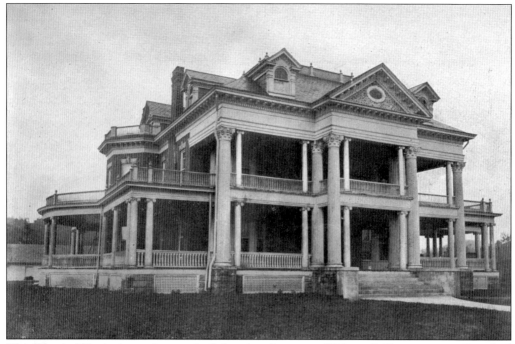
This Classical Revival mansion was built by oil and gas mogul Edwin G. Davisson near Crawford as a summer residence in 1902. A walk through its many rooms furnished with Davisson family heirlooms gives visitors a sense of life there in the first half of the 20th century when it was a meeting place for senators, governors, and opinion makers. (Photograph by Joseph B. Gissy; courtesy of BRO.)

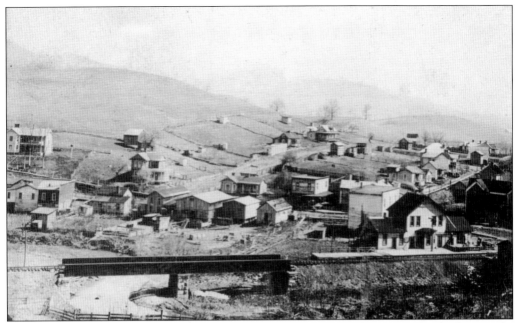

Walkersville was a booming village in the first quarter of the 20th century. In the lower-right corner of the photograph is the train station. Behind the train station is the store and Masonic lodge. Walkersville High School had not been built, dating this view to before 1921. (Courtesy of Dick Duez.)

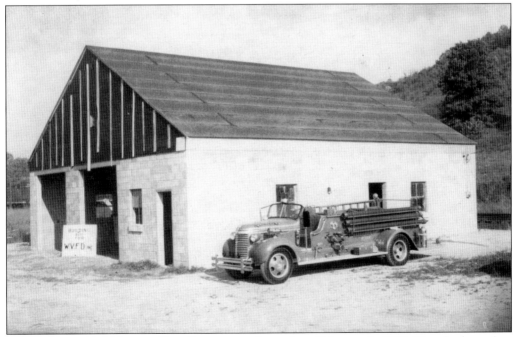

The Walkersville Volunteer Fire Department formed on February 7, 1963. Shortly thereafter, Granville Cayton gave the department some land for a fire station. That summer, construction was well underway when the department acquired its first "real" fire truck, a Mack convertible, from the Sutton Fire Department. (Courtesy of WD.)

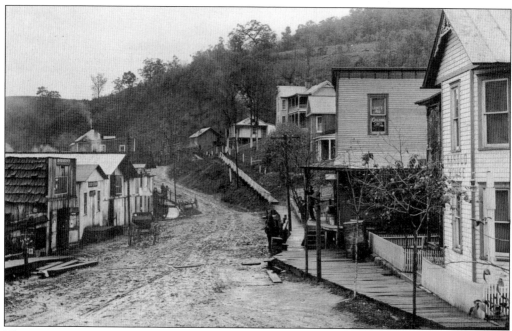

These two images were captured at what is today the corner of Jacksonville Road (above) and Crane Camp Road (below). The buildings clustered on the right and left of the road were part of what was considered the business district in the above image. The Harold House, a hotel operated by Sara Ann Harold, is in the far right of the above photograph and far left corner in the image below. In the 1960s, the bottom portion of the structure served as the post office. The building immediately beyond it on the right is probably the Harold and Wilson General Store. On the left side of the road in the above picture, the first building was at one time a blacksmith shop. Today some of these same buildings still stand at Walkersville. (Courtesy of Dick Duez.)

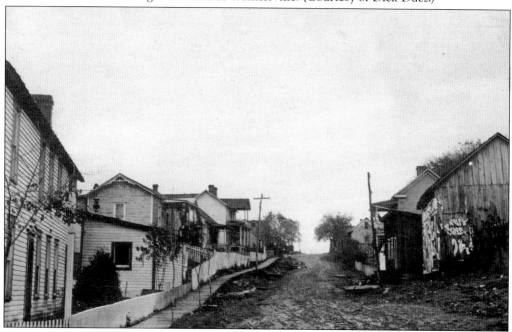

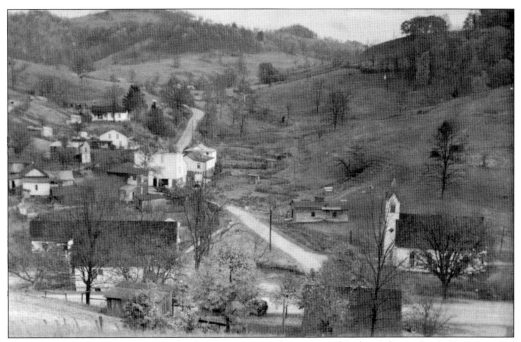

The photograph above gives a bird's-eye view of the town of Ireland from the hill above the entrance to the Duffy-Wildcat Road. Ireland had two Methodist churches, as can be seen in the top photograph. The churches faced each other and were separated only by the county road and a creek. The M. E. Church, North, dedicated in 1891, was located on the east side of the road. The M. E. Church, South was on the west side and dedicated in 1894. Sometimes joint services were held, but separate services were the regular procedure. The two congregations joined in 1939, and the South building was torn down. The extant church, pictured below in its original location, was moved several hundred yards to the east to get it out of the flood plain. It continues to have an active congregation. (Above, courtesy of BRO; below, courtesy of HCPD.)

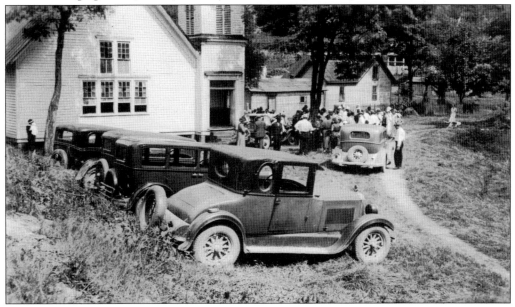

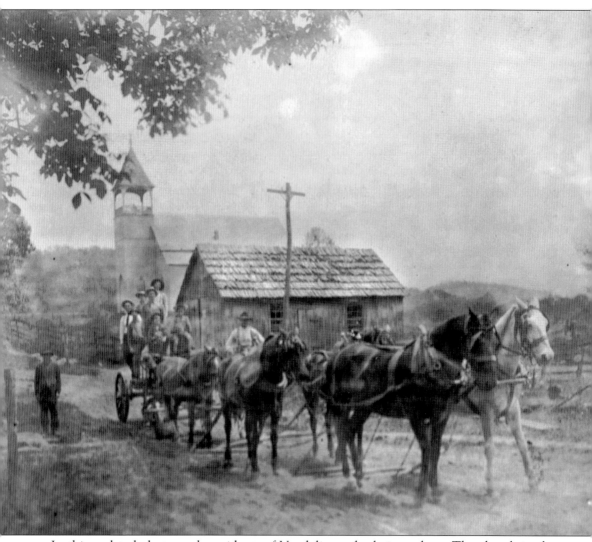

In this undated photograph, residents of Vandalia grade their roadway. The church in the background is the Methodist Episcopal's Asbury Chapel or "the lower church." It was located below the road as one goes into the village. In 1939, by order of the Methodist Conference, this church and the Methodist Protestant Church (Hall's Chapel) were combined. However, both congregations were reluctant to give up their respective buildings. They solved their problem by worshipping in one church for six months and then switching for a similar time to the other. They finally came together and built the current church on the M. E. lot. It was moved to its present location near the community building in the 1980s by the U.S. Army Corps of Engineers to make way for backwaters of Stonewall Jackson Lake. The man at the far left is William Bradshaw Linger. (Courtesy of HCPD).

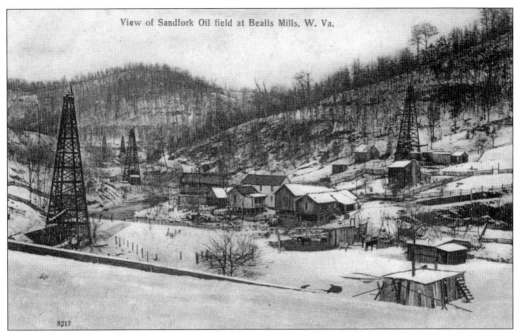

Oil wells in the Sandfork Oil Field off Copley Road, as well as fields in other areas of the county, made many Lewis County residents wealthy. A well just a couple of miles down the road from this oil field in Bealls Mills started the boom in the Sandfork field. (Courtesy of BRO.)

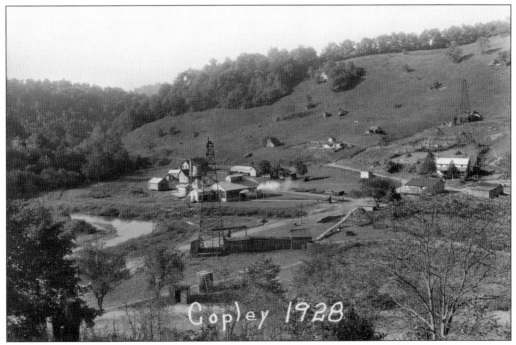

In 1928, the pumping station on what was the Patrick Copley farm at Copley stood as testament to the great oil strike that took place there in September 1900, when wildcatters struck oil for the South Penn Oil Company. Today the site is owned by Equitrans. (Photograph by Archie Ellis; courtesy of HCPD.)

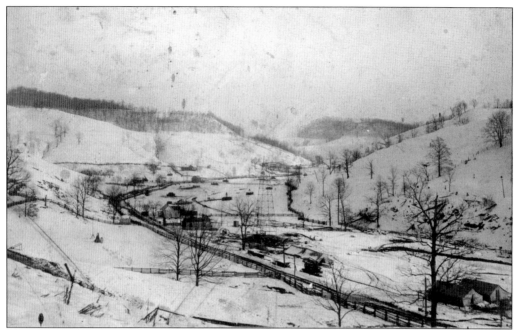

Camden No. 1 well was drilled in 1899 at the mouth of Dry Fork on Polk Creek about where Moody's mobile home dealership is today. Its success sparked a spate of drilling in the county, which resulted in the county's first oil and gas boom. The well in this undated picture was located about where Dominion's Camden Station is today. (Courtesy of Dannie Gum.)

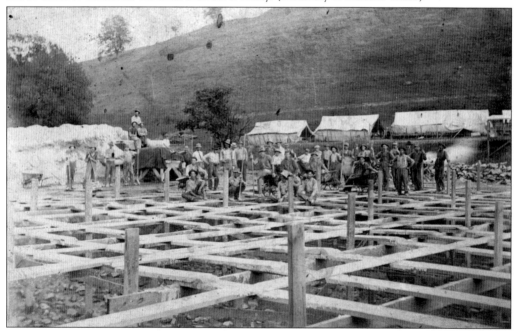

In 1910, these men had just completed construction of the framework prior to pouring the foundation of the first Camden Station, which was built just to the west of the present station's location. The station was completed in 1911. The current station at this location was built in 1962. (Courtesy of Dannie Gum.)

The Weston and Glenville Stage was pulled by mules. One of the stops on the route was the Camden Station, west of Weston, which is seen in the background. The driver is believed to be William S. Kern. The photograph is dated November 12, 1913, on the back; however, it appears in the image that Camden Station is under construction in the background. (Courtesy of John Gissy.)

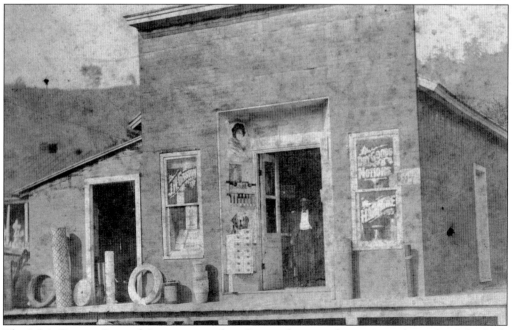

The J. M. Gaston General Store operated in Gaston for several years on either side of the 20th century. The store window advertises dry goods, notions, and hardware. The 1891–1892 *West Virginia Gazetteer* also shows that Gaston was a furniture dealer. (Photograph by Roy Peterson, Weston, West Virginia; Courtesy of Don Henderson.)

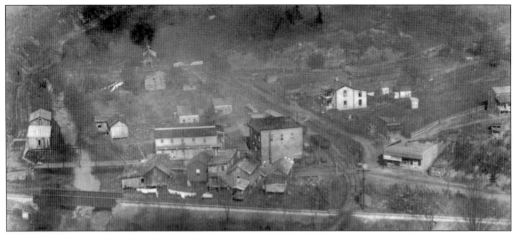

Fully visible just right of center in the lower part of this 1907 era photograph is the crossing of the Coal and Coke and B&O Railroad tracks, both of which served Orlando. The small village is perched along Oil Creek on the southwestern edge of the county. Crossing the creek on the left are the railroad bridge and an iron-span bridge that carried man and beast between Lewis and Braxton Counties and points beyond for several decades. (Courtesy of BRO.)

Researchers believe that this image called "Camping Place by New Church Between Weston and Buckhannon, W. Va." shows the Valley Chapel Methodist Church, now abandoned and part of the Tree Farm owned by the late Charles and Helen Hall. The photograph was taken on July 11, 1884, according to information attached to it by the photographer. Note the buggy and pitched tent by the fence. (Photograph by Thomas and Walter Biscoe; Courtesy of WVRHC.)

Five
EVENTS, RECREATION, AND SPORTS

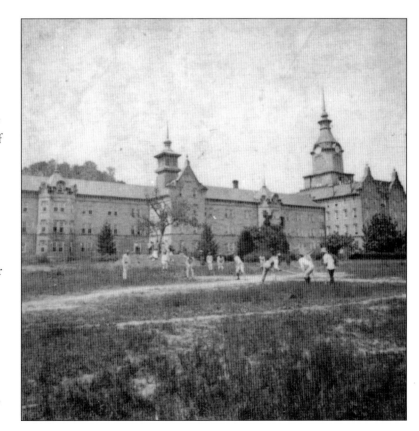

This rare 1884 stereo view card showing a game of baseball in front of Weston Hospital is probably the earliest sports picture in Lewis County. The players appear to be in uniform and the gentleman behind the catcher is wearing a top hat. The grounds of the hospital have served the community as a location for sports and events for over a century. (Courtesy of HCPD.)

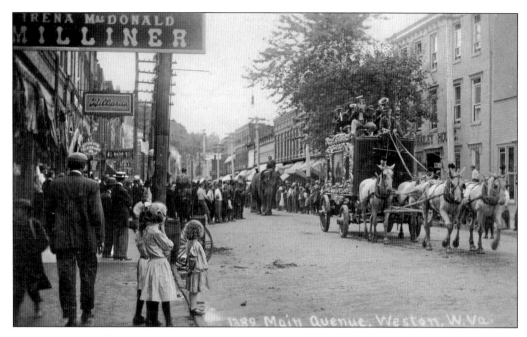

The Frank A. Robbins All Features Circus offered two performances on September 13, 1910. "A Grand Free Street Parade" was held at 10:00 a.m. that day. The large elephant immediately behind the bandwagon was named Queen. When the season was over she was intentionally poisoned in the circus's winter quarters in Jersey City, New Jersey, after trampling her keeper, Robert Shields. The top photograph depicts the circus parade looking south on Main Avenue. The circus wagon is in front of the Bailey House, where Citizen's Bank now stands. The bottom photograph captures the elephants in a view looking west on Second Street. (Photographs by G.H. Broadwater; above, courtesy of BRO; below, courtesy of John Gissy.)

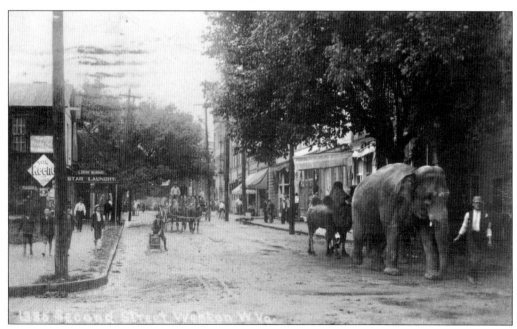

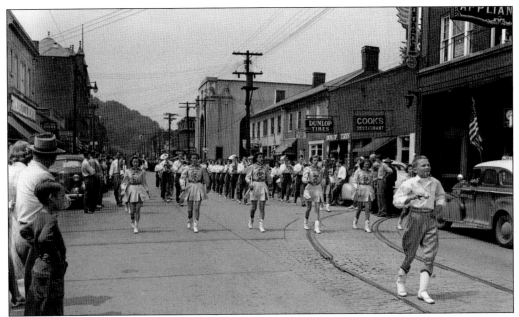

The Weston High School marching band strutted down Main Avenue in the Memorial Day parade in 1948. Their performance was captured on film as they passed the Traction Building where the law offices of W. T. Weber Jr. and his son, W. T. Weber III, are located in 2010. Bernard Kuhn was drum major. The majorettes, from left to right, were Alice Hill, Margie Eskew, June Crook, Peg Fultineer, Pat Flesher, and Barbara Kuhn. (Photograph by Archie Ellis; courtesy of HCPD.)

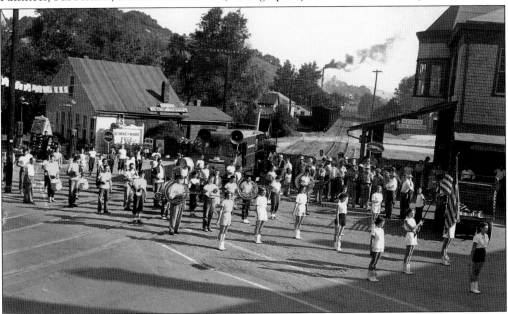

In August 1951, there was a major cleanup of the West Fork River. The Weston High School Band kicked off the event, which organized at the bus station across from the West Second Street bridge. In the left rear of the band is the Spur gas station, where gas purchasers would get free dinnerware. In the rear of the same building was the Cream Station, where dairy farmers would sell their cream. (Photograph by Archie Ellis; courtesy of HCPD.)

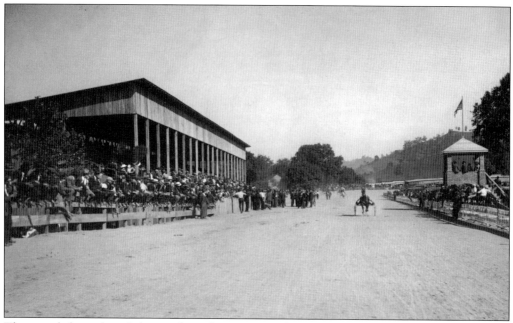

The crowded stands and the number of men sitting along the racetrack fence are witness to the interest that sulky racing generated at the county fairgrounds at Bendale in the early decades of the 20th century. This image is from 1922. (Courtesy of Davis Studio.)

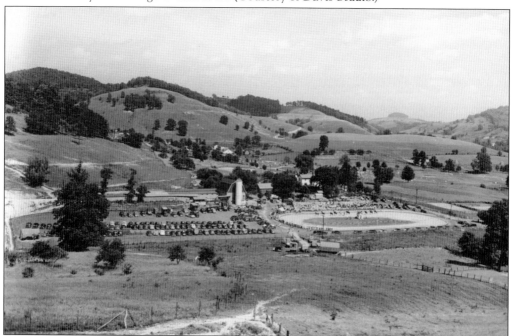

A horse show sponsored by the Lewis County Boot and Saddle Club is in progress in this 1940s-era photograph. The image was shot from the hillside to the west of the Alexander and Emily Trefz farm on what is today called Old U.S. Route 33. Note the Masonic cemetery in the background, where there were many fewer grave markers than today. (Photograph by Archie Ellis; courtesy of HCPD.)

Until Lake Riley was built and opened in 1945 by John and Joe Krause and their sisters, Anna, Pat, and Gertrude, county residents contented themselves with swimming in the West Fork River or traveling to other counties for recreational opportunities. The complex included the county's first golf course, which was designed by Clarksburg professional golfer Jimmy Spencer. While not of the magnitude of today's Stonewall Resort, rental cabins, horseback riding, fishing, and a small eatery made this the county's first resort. Today John and Connie Metheny own the lake and its environs. (Courtesy of BRO.)

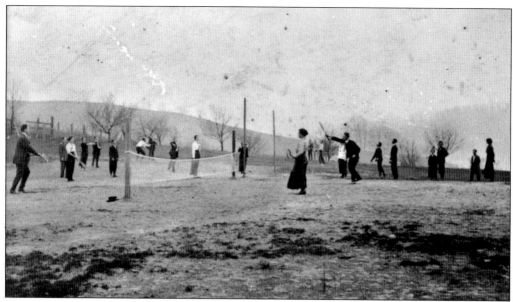

This early image depicts a racket sport, probably either badminton or tennis, being played at Jane Lew at an unknown location. Both badminton and tennis were popular in America at the period of this photograph. (Courtesy of HCPD.)

The late Tom Miles built a pond and stocked it with fish on his land at Horner. In the late 1940s and 1950s, he would host fishing tournaments for children of the area. These are the winners of one of those tournaments. The pond has recently been filled and the lot is for sale. (Photograph by Archie Ellis; courtesy of HCPD.)

The 1915 Weston High School baseball team, photographed in front of the Weston Hospital, is identified as (first row) Grant, John Krause, unknown, Kane, and Riley; (second row) Drummond, McCoy, Vassar, unknown, Blair, Workman, and Cox; (third row) S. Fuccy, Bailey, J. Fuccy, Joe Krause, and Shaffer. (Courtesy of Jim Pudder.)

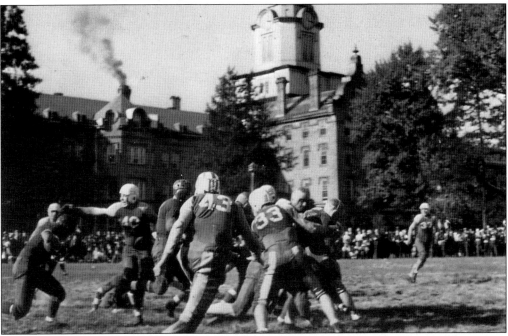

The lawn in front of the State Hospital was the playing field for the Weston High School football team before 1938. Teams found the hospital field challenging because scoring a touchdown involved running around a tree in one of the end zones. This is the 1937 team playing an unnamed opponent. They played eight opponents and lost only two games. The only identified player is number 40, Daril W. Stalnaker. (Courtesy of Joy Stalnaker.)

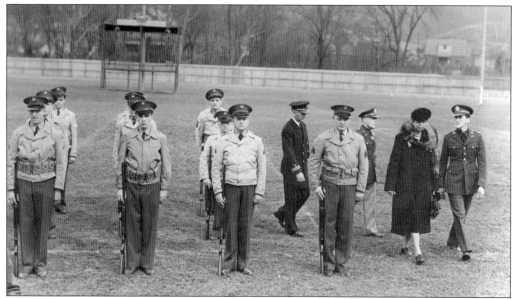

First Lady Eleanor Roosevelt visited Lewis County on February 25, 1944. Escorted by the state guard unit from Weston and accompanied by Gov. Matthew M. Neely, she met with local citizens and school children at the Weston High School stadium before visiting Jackson's Mill, where she met with navy cadets who were training there. In the above picture, Roosevelt is escorted by Capt. Minter Ralston Jr. The two officers walking in the back are Lt. J. F. Gremeker (the commander of the naval school at Jackson's Mill) and Lt. Charles E. Robert (right). Identified in the first row are Lee Borchert (second from left) and Harley Hefner (right). The center man in the third column from the left is Al Erbe. (Photographs by Archie Ellis; above, courtesy Minter Ralston III; below, courtesy of David Bush.)

Six

CRISIS, CONFLICT, AND ADVERSITY

Davy Forinash, a resident of the Lewis County Poor Farm on Grass Run, hand-loomed rugs during his residency there in the 1930s and 1940s. The poor farm opened about 1870 and closed in 1948. Counties cared for their own indigent prior to the availability of federal and state government programs. Those who were able were expected to work on the farm and be productive. (Photograph by Archie Ellis; courtesy of Weston Democrat.)

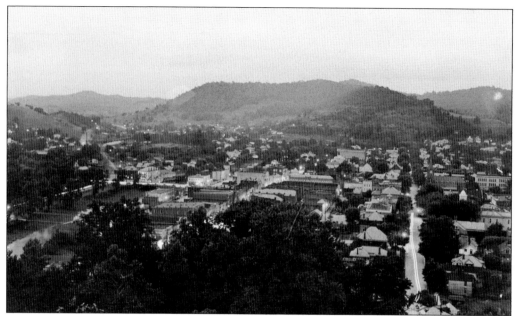

This photograph depicts Weston five minutes before a blackout on July 10, 1942. As part of civil defense during World War II, periodic drills were conducted when Weston would go dark to prevent visibility from the air. This practice was common throughout the United States in preparation for possible enemy air raids on American soil. (Photograph by Archie Ellis; courtesy of HCPD.)

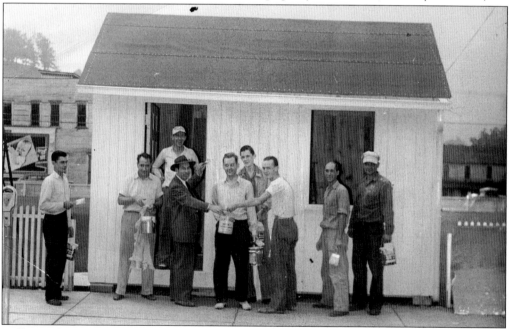

Millions of Americans purchased war bonds during World War II to help finance the American war effort. Lewis Countians were no exception. This little building, located on the north side of the Citizens Bank, was a campaign site for war bond sales. Among those pictured are Frank Frye (in business suit) and to his right, wearing glasses, is Frank Whelan. Immediately behind Whelan is Matt Harrison. On the far right is Harley Hefner. (Courtesy of Minter Ralston III.)

During World War II, selective service drafted men in all classes—single, married, and married with children. Daril W. Stalnaker fell in the third category. In October 1942, knowing he was about to be drafted, he enlisted in the U.S. Navy. He managed to come back home just one time during his three years of service. In this photograph, he kisses his wife good-bye while their young son, Jack, looks on. (Courtesy of Joy Stalnaker.)

Clayton Woofter, Robert L. Bland Jr., and Lawrence Chapman, all veterans of World War II, were among those attending an annual Veterans Day service in front of the Lewis County Courthouse. (Courtesy of WD.)

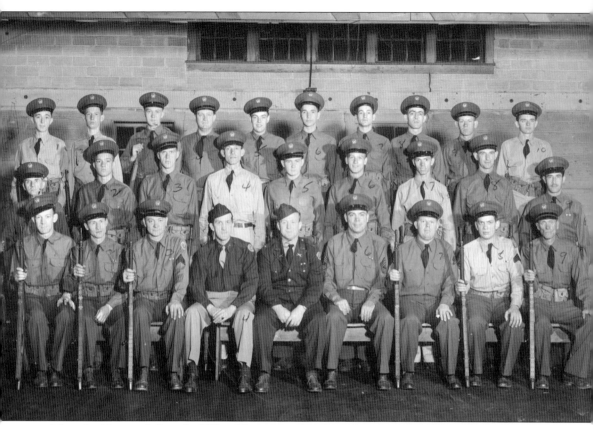

After the National Guard of West Virginia was mustered into national service early in 1941, the state had no military organization for protection until the West Virginia State Guard was provided for by an act of Congress in 1941 and by State Senate Bill 35. These Lewis County men were Company E, a part of the 1st Regiment, which was organized for the northern and eastern part of the state. The southern unit was 2nd Regiment. Pictured from left to right in this 1943 photograph are (first row) Bill Chapman, "Dude" Cottrill, Harley Hefner, Minter Ralston Jr., J. Barnette, Carl Phillips, unknown, ? Fisher, and ? Hefner; (second row) Al Erbe, unknown, Joe E. Craft, unknown, Jimmy Ralston, ? Schroeder, ? Boggs, and two unknown men; (third row) Jack White, unknown, Bob Henderson, unknown, Jim Vassar, Jim Pudder, Jack Skinner, and three unknown men. (Courtesy of Minter Ralston III.)

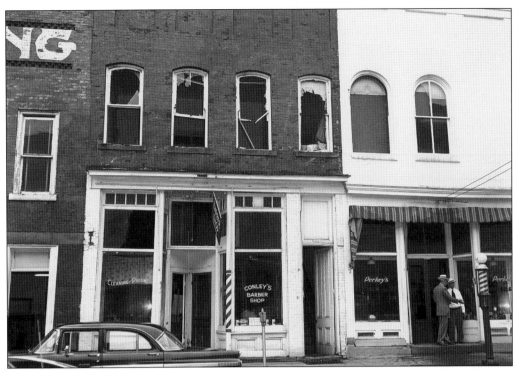

These photographs show damage to Weston businesses from a 1959 windstorm. Conley's Barbershop was on Main Avenue, two doors down from what was then the city police station. Andrews Motor Company was located at the corner of Main Avenue and East First Street. The Andrews Motor Company building pictured here stands at the end of Water Street and the lettering on the side of the building remains barely visible today. Although these and other pictures kept by the photographer imply there was great damage throughout the town, efforts to learn more about this windstorm from newspapers of the day have not been successful. (Photographs by Bob Davis, Courtesy of Davis Studio.)

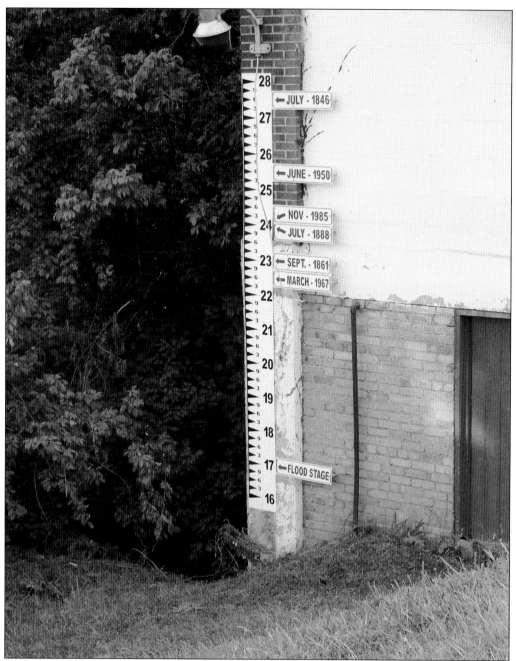

This flood gauge on the side of the former fire department building on Water Street at the edge of the West Fork River in downtown Weston tells part of the story of the floodwaters in the county over the decades. No details of flood depths or damage exist prior to the 1846 flood, when the water reached an estimated 27.5 feet. The June 1950 flood, often referred to as "The Big Flood," was the most destructive ever recorded in the area and measured 25.5 feet on the morning of June 25. The 1985 flood predated the completion of the flood control Stonewall Jackson Dam. The January 22, 1917, flood was 20.2 feet at 4:00 a.m. that morning. (Photograph by Joy Stalnaker; courtesy of WD.)

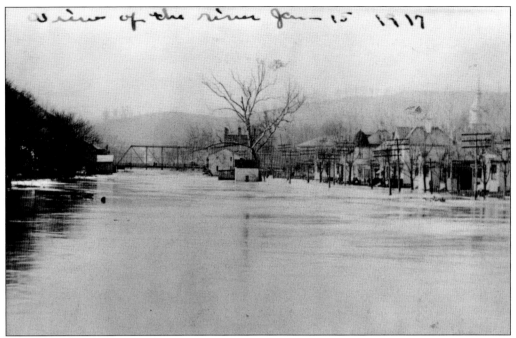

This January 15, 1917, view of the West Fork River looks south toward the bridge on West Second Street. The river had not yet crested when this photograph was taken. River Avenue, on the right, is under water and the tower of Weston Hospital is visible on the right edge of the photograph. (Courtesy of HCPD.)

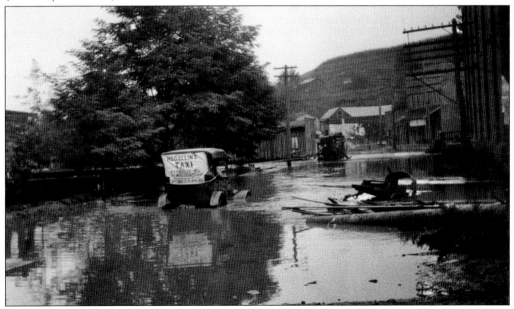

Hacker's Creek escaped its banks on May 12, 1924, and flooded Main Street in Jane Lew. The West Fork River, into which the creek eventually emptied, reached a flood depth of 20.5 feet. In the photograph, M. S. Collins Taxi of Glenville, West Virginia, moves ahead through the flooded street. The sign on the back of the vehicle also advertises the Gilmer County Fair in September 1924. (Courtesy of Davette Saeler.)

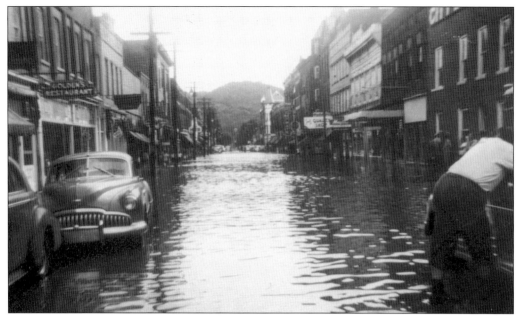

This 1950 photograph looking north up Main Avenue in Weston shows the high water that flooded the city on June 25 when water crested (on average) at 1,019.34 feet above mean sea level. The elevation marks the pre-Stonewall Jackson Dam 100-year flood plain boundary in Weston. (Courtesy of Davis Studio.)

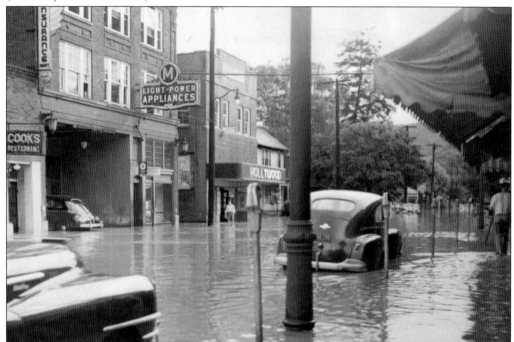

Main Avenue is consumed by water in this 1950 photograph taken across from the Traction and Barnes buildings looking north. Most retail businesses on Main Avenue suffered total loss or substantial damage. As a result, some closed and never reopened. The 1950 flood was the second greatest flood in Weston, the first having occurred in July 1846. (Courtesy of Florence Ellis.)

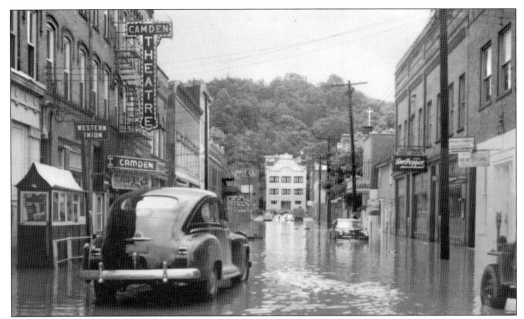

Another photograph of the 1950 flood looks east from the corner of Main Avenue down Second Street. Camden Theatre is visible on the left side of Second Street. The year 1950 is memorable for its weather extremes. Lewis County would be hit by a snowstorm on Thanksgiving Day 1950 that would dump nearly 45 inches of snow on the county, a record for a single snowfall. (Courtesy of Florence Ellis.)

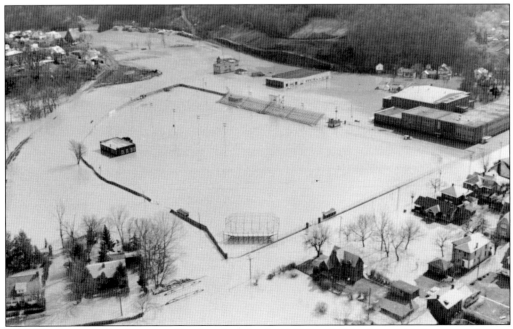

Although not one for the record books, the March 1967 flood did substantial damage to homes and businesses in Lewis County. The photograph depicts the extent of the flooding in Weston, focusing on the area around the athletic field on Court Avenue and East Third Street. (Courtesy of Davis Studio.)

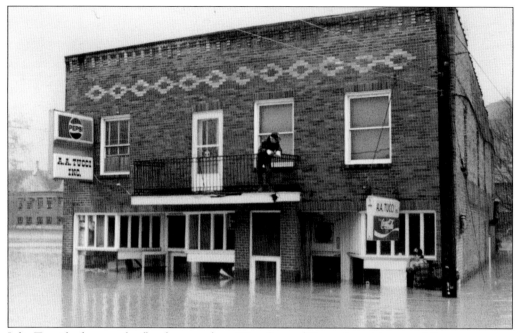

Julie Tucci looks over the floodwaters along West Second Street from his second floor apartment over A. A. Tucci's Bar and Grill during the flood of November 4–5, 1985. It was the third highest on record. Had it not been for the partially completed Stonewall Jackson Dam, the water would undoubtedly have set a record for being deepest of all time. (Courtesy of WD.)

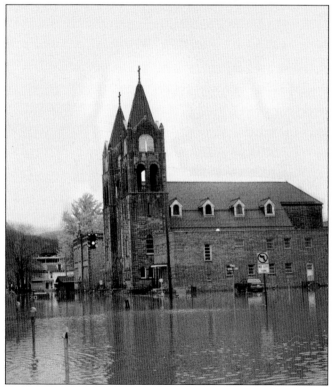

St. Patrick's Church and School sit in the middle of a lake on Center Avenue in this November 1985 flood picture. The 1985 flood caused devastation not only in Lewis County but also throughout northern and eastern West Virginia. (Courtesy of Davis Studio.)

Seven
INDUSTRY AND DEVELOPMENT

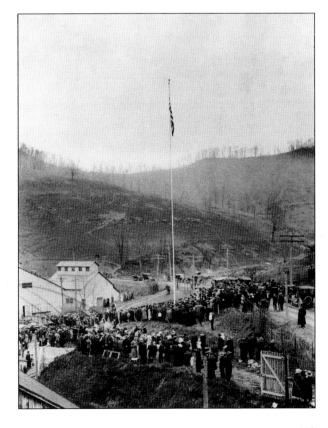

For much of the 20th century, glass was the leading industry and employer in Lewis County. Over the years, many companies have produced, cut, and decorated glass in the county, including Borchert Glass, Brilliant Glass, Colonial Glass, Lewis County Glass, Louie Glass, Mountaineer Glass, and West Virginia Glass Specialty. This vintage photograph captures the dedication of an unidentified early Weston glass plant. (Courtesy of WVRHC.)

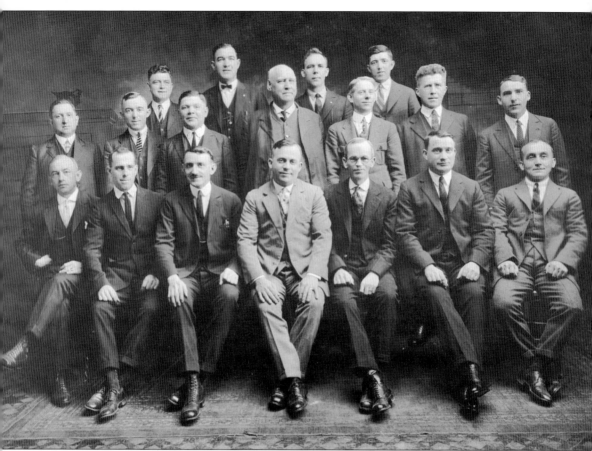

These men were the founders of the glass industry in Weston. About 1920, Dr. M. S. Holt, a physician to these men and their families, bought a defunct bottle plant in Weston for them to start a new glass plant. He was the only stockholder not employed in the factory. Pictured from left to right are (first row) Frank Model, Henry Model, Elglebert Hager, Louis Wohinc, Mr. Lawrence, Karl Wohinc, and Louis Schrader; (second row) Henry Tomasche, John Pertz, Godfrey Weber, Dr. Holt, Joe Hager, Rudolph Bauer, and Frank Langhanse; (third row) John Weber, Jumbo Ransinger, Ed Bascisko, and August "Gus" Weber. (Courtesy of WVMAG.)

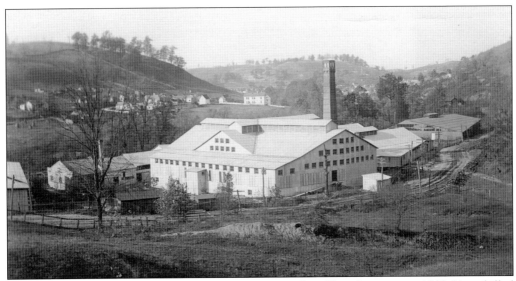

The George W. Grant family established Crescent Window Glass Company in 1903. Very skilled workers produced and cut hand-blown window glass in this plant. The company was sold in 1921 to Inter-State Glass Company. In 1929, the plant was refurbished to become West Virginia Glass Specialty Company. (Courtesy of Don Henderson.)

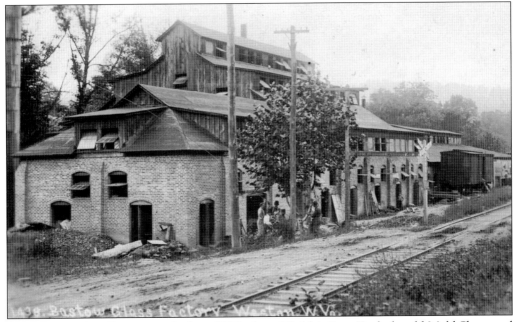

The Bastow Glass Factory was built in 1909 where Hinkle's Boat Yard, the old Mold Shop, and a used car lot now stand. It was owned and operated by Harry Bastow until 1911, when a strike caused its closure. In 1919, the factory became Weston Glass Company and was under the control of Louis Wohinc. (Photograph by G. H. Broadwater; courtesy of BRO.)

Austrian-born Louis Wohinc (1888–1950) provided the leadership that brought the glass industry in Lewis County from its infancy to its heyday, when high quality blown glass was sold worldwide to buyers. At one time, Wohinc directed and operated five affiliate glass plants in Weston. The industry, unsurpassed in county history, began to decline in the early 1980s as glass manufacturing in other countries began to produce quality glassware at lower prices. (Photograph by Archie Ellis; courtesy HCPD.)

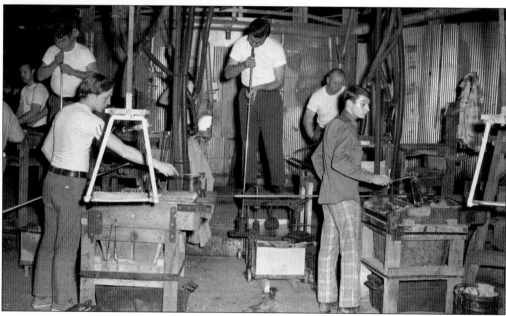

From 1926 until 1972, Louie Glass Company produced numerous glass products, all of them mouth-blown, as demonstrated in this image. Following Louis Wohinc's death, his daughter Margaret Wohinc operated the plant. She sold the company in 1972, at which time the plant was operated as a subsidiary of Princess House. In 2000, it began operations as Glass Works West Virginia, and closed in 2002. (Photograph by Bob Davis; courtesy of Davis Studio.)

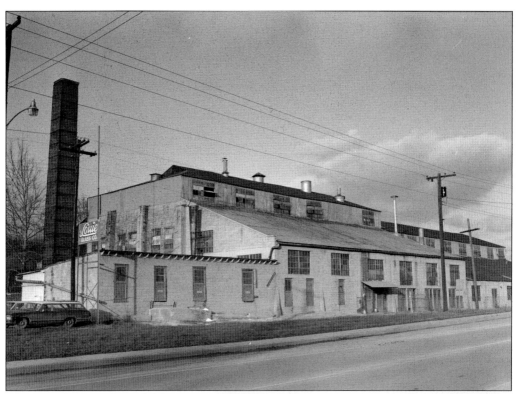

The manufacture of mouth-blown glass was a prime industry in the county for most of the 20th century. Among the leading glass plants was the Louie Glass Company on U.S. Route 33 east of Weston. These images show the plant from two different perspectives and show the factory before the highway in front of the plant was relocated and widened. (Photographs by Bob Davis; courtesy of Davis Studio.)

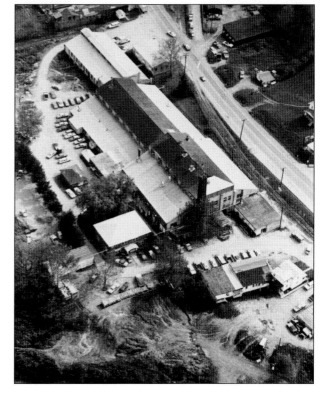

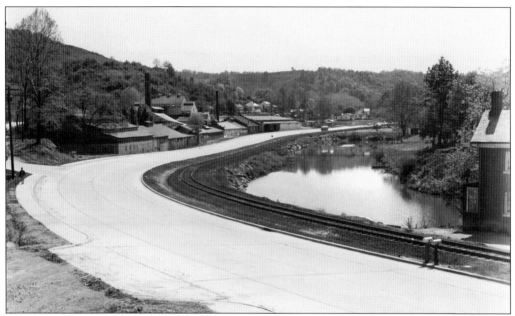

Archie Ellis snapped the above image as much to display the newly widened section of U.S. Route 19 south with its adjacent railroad tracks as to focus on the West Virginia Glass Specialty Company, a leader in the manufacture of glassware in Lewis County. In 1929, the old Crescent Window Glass Factory was refurbished, and the West Virginia Glass Specialty Company began operation in February 1930. In 1935, a decorating department was added. It employed as many as 560 workers at one time, and closed in November 1986. (Above, photograph by Archie Ellis, courtesy of HCPD; below, courtesy of HCPD.)

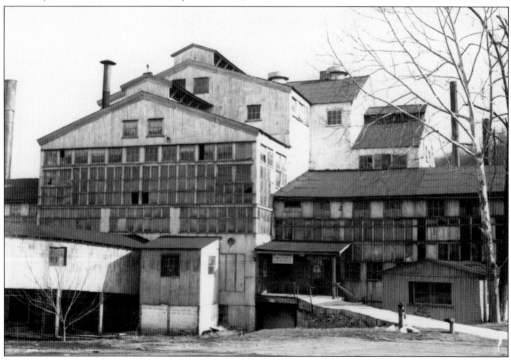

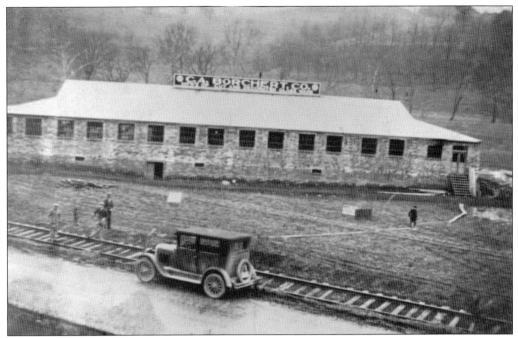

The manufacturing of fine glass products was the mainstay of the Lewis County economy for much of the 20th century. C. A. Borchert, with partners Congressman Andrew Edmiston and attorney Kenneth Kurtz, manufactured cut and decorated glassware as the C. A. Borchert Company. The Borchert glass factory burned in 1958. (Above, courtesy of WVMAG; below, courtesy of Davis Studio).

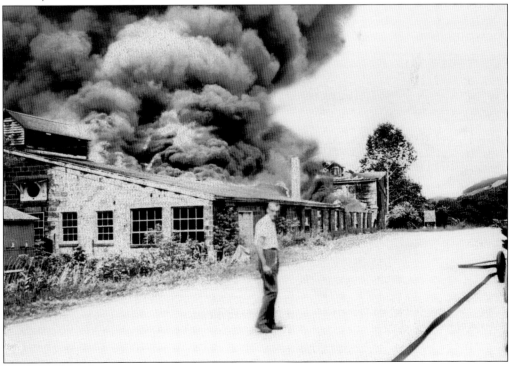

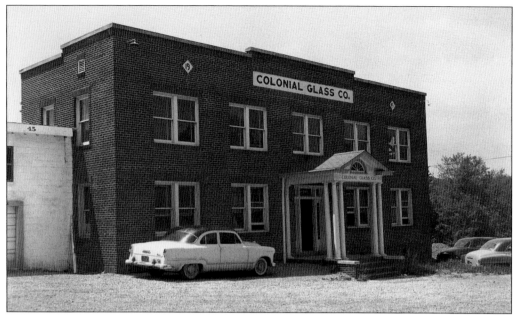

In 1945, C. A. Borchert (1897–1966) started Colonial Glass Company at Deanville to help meet the growing demand for fine decorated glassware. Over the years, the company continually added to its capacity to produce its own hand blown glassware in addition to decorating and cutting. The plant burned in November 1975 as a result of a fire caused by an electrical short. It was never rebuilt. (Photograph by Bob Davis, courtesy of Davis Studio.)

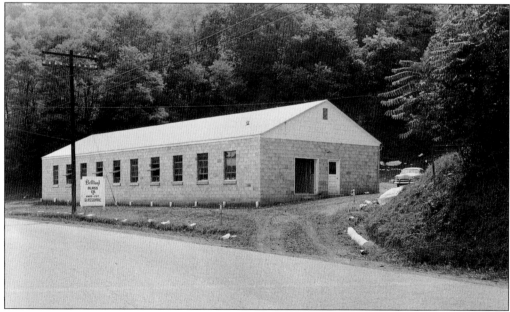

Jack Romel formed Brilliant Glass at Edmiston in 1951. In September 1956, he opened a new facility at McGuire Park. The company was named for one of its first pattern designs. Brilliant employed as many as 40 people in two shifts at its peak hand-cutting glass blanks purchased from local glass plants. The business was closed in October 1984. (Photograph by Bob Davis, courtesy of Davis Studio).

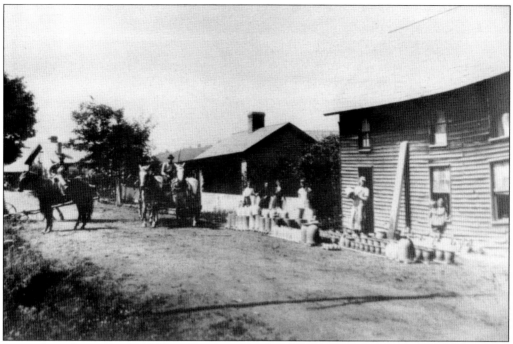

Located on the west side of Main Street, across from Jane Lew School, Jane Lew Pottery was purchased as an operating pottery by Josiah P. Parker from John T. Hacker in 1865. Parker sold the pottery to Seymour A. Colvin and his sons in 1876. The pottery was operated into the early 20th century. Pictured above in front of the pottery are Noble Colvin (doorway), Jim Colvin, Mrs. Colvin (left), and Bob Colvin in the wagon (Courtesy of HCPD.)

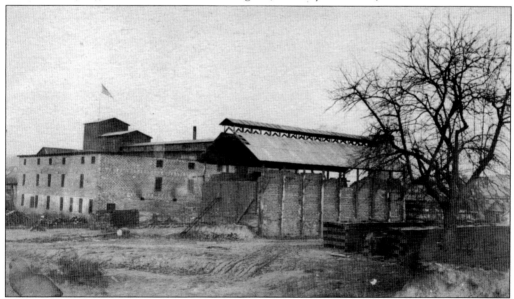

Van Buren Flesher started a brickyard in Jane Lew in the late 1800s on what is now the east side of U.S. Route 19 (Straley Addition). Clay for production came from the hill behind the plant. After Van Buren Flesher's death in 1898, his fifth son and sixth child, Fred, took over its operation. He continued to operate it until his own death on October 14, 1953. (Courtesy of BRO.)

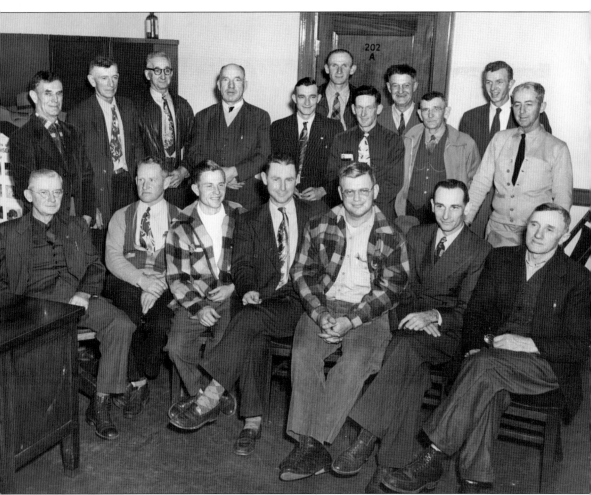

This image was identified by the late photographer Archie Ellis, among some images recently donated to the Hacker's Creek Pioneer Descendants, as being a Farm Bureau picture taken in 1951. Mary K. Hull and Dick Cronin have helped identify some of them. From left to right are (first row) James White, Carl Stalnaker, unknown, Jack Linger, unknown, Burl Gall, and George Shieffer; (second row) ? Hammer, Albert Jewell, Argyle Bonnett, John Harley Hull, unknown, Maxwell Martin, unknown, and Victor Hardman; (third row) unknown, Creed Summers, and Dick Cronin. (Photograph by Archie Ellis; courtesy of HCPD.)

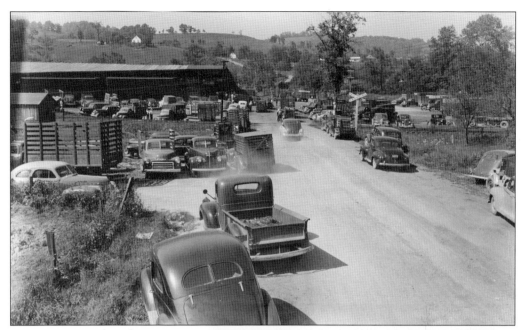

The Weston Stockyards at Deanville has been "the happening place" for farmers of Lewis County and surrounding counties since August 7, 1934. When this image was captured in the 1940s, Lewis County was still a largely agrarian economy, with farmers raising cattle and sheep in large numbers. Most farm families looked forward to Saturdays and sale day at Deanville. (Photograph by Archie Ellis; courtesy of HCPD.)

The 4-H (head, heart, hands, and health) has been very active in Lewis County since its inception. While originally focused on educating rural youth in new agricultural technology, the organization has grown to include the teaching of leadership, citizenship, and life skills through activities, projects, and events. In this 1951 photograph, Mida (Bailey) Peterson displays her 4-H strawberry project. (Courtesy of West Virginia University Extension Office-Lewis County.)

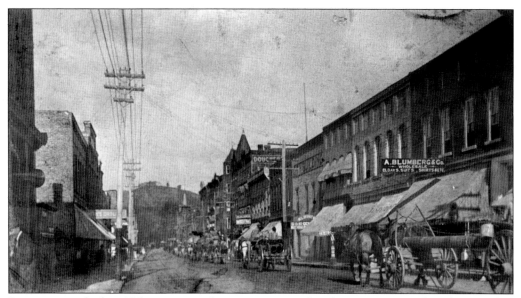

Beginning in the late 19th century and continuing to today, the extraction and marketing of oil and gas has been an important resource for the county's economy. These many wagons bear pipe from Weston to where oil- and gas-rich fields lay below the surface. The scene was captured on Main Avenue around 1910. (Photograph by Merchant's Photographer, Hendricks, West Virginia; courtesy of BRO.)

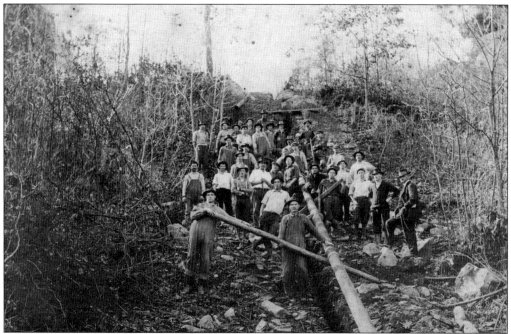

During the first half of the 20th century, hundreds of miles of pipeline were laid across the county, carrying natural gas and oil from wellheads on nearly every farm to processing plants and pump stations in distant places. The laying of pipe was difficult manual labor without the benefit of modern equipment. This photograph depicts a 1915 Weston Hope Natural Gas Company crew. (Courtesy of BRO.)

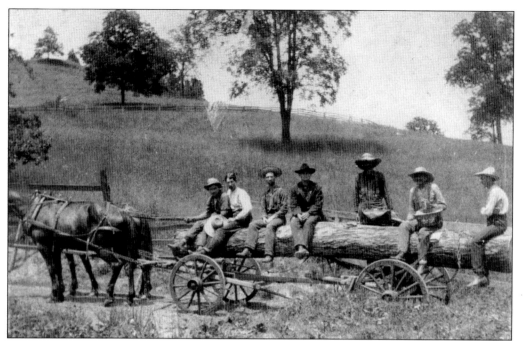

The timber industry has long provided an economic boost to the county's economy. This photograph was taken in Vadis in the early 20th century. (Courtesy of HCPD.)

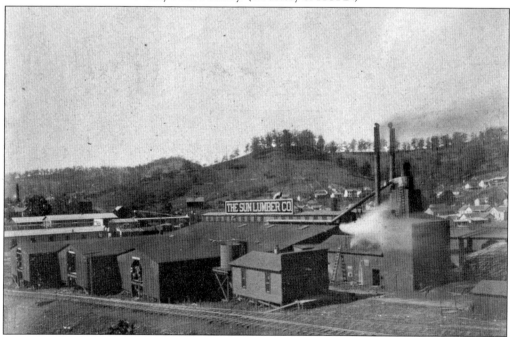

Local timber man Melvin Burr Sprigg (1891–1961) was the leading force behind the success of Sun Lumber Company, which was located at Deanville. Although he was a very successful businessman, he never forgot his roots. He established a trust fund that, well into the 21st century, benefits a number of non-profit organizations in the county, including fire departments and Stonewall Jackson Memorial Hospital. (Photograph by Joseph B. Gissy; courtesy of BRO.)

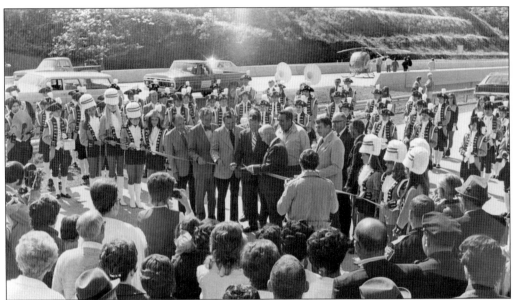

The widening of U.S. 33 East from I-79 near Weston was part of the Appalachian Regional Development Act of 1965. Local citizens as well as the Lewis County High School Band looked on as Gov. Arch Moore opened the section of Corridor H through Horner. The men holding the ribbon are, from left to right, State Sen. J. D. Hinkle of Upshur County, unknown, State Sen. William R. Sharpe Jr. of Lewis County, unknown, Gov. Arch Moore, and unknown. (Courtesy of WD.)

The stretch of I-79 from Nutterfort at Exit 115 to the Jane Lew interchange pictured here was opened December 22, 1971. Although it would be September 1973 before the interstate would open from the Pennsylvania line to Exit 99 at U.S. 33 near Weston, the superhighway significantly lessened the trek between Weston, Clarksburg, and other points to the north. It also opened up the Jane Lew area for significant development, which became the Jane Lew Industrial Park. (Courtesy of Davis Studio.)

The first of 106,625 cubic yards of concrete were poured for the Stonewall Jackson Dam in June 1984. Two years and three months later, on September 3, 1986, the last cubic yard of concrete was poured. In the photograph at right, the U.S. Army Corps of Engineers officials and personnel from the contractors Wiley and Jackson and the J. F. Allen Companies attended the unofficial ceremonies marking the event. The dam and its surrounds were officially completed and dedicated in 1990 just after this aerial photograph was recorded. (Courtesy of WD.)

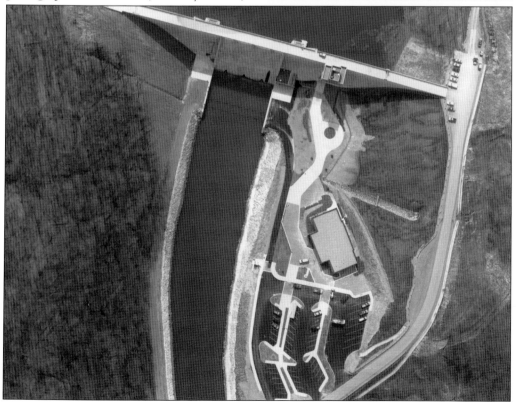

www.arcadiapublishing.com

Discover books about the town where you grew up, the cities where your friends and families live, the town where your parents met, or even that retirement spot you've been dreaming about. Our Web site provides history lovers with exclusive deals, advanced notification about new titles, e-mail alerts of author events, and much more.

Arcadia Publishing, the leading local history publisher in the United States, is committed to making history accessible and meaningful through publishing books that celebrate and preserve the heritage of America's people and places. Consistent with our mission to preserve history on a local level, this book was printed in South Carolina on American-made paper and manufactured entirely in the United States.

This book carries the accredited Forest Stewardship Council (FSC) label and is printed on 100 percent FSC-certified paper. Products carrying the FSC label are independently certified to assure consumers that they come from forests that are managed to meet the social, economic, and ecological needs of present and future generations.

FSC
Mixed Sources
Product group from well-managed forests and other controlled sources
Cert no. SW-COC-001530
www.fsc.org
© 1996 Forest Stewardship Council

Find Your Place in History.